IMAGES
of America

NEW JERSEY WINERIES

On the cover: This photograph was taken in 1944 in Egg Harbor City, New Jersey, in the Renault Winery champagne cellar. Sales representatives often met at the Renault Winery to develop marketing strategies and plan out sales routes. At that time, door-to-door sales to distributors was a fruitful way to earn a living and to put Renault wine and champagne in the hands of liquor stores and consumers. The volume of demand for Renault Champagne was so great that the winery had to operate seven days a week. (Courtesy Renault Winery.)

IMAGES
of America

NEW JERSEY WINERIES

Jennifer Papale Rignani

ARCADIA
PUBLISHING

Published by Arcadia Publishing
Charleston SC, Chicago IL, Portsmouth NH, San Francisco CA

Printed in the United States of America

Library of Congress Catalog Card Number: 2007941113

For all general information contact Arcadia Publishing at:
Telephone 843-853-2070
Fax 843-853-0044
E-mail sales@arcadiapublishing.com
For customer service and orders:
Toll-Free 1-888-313-2665

Visit us on the Internet at www.arcadiapublishing.com

This book is dedicated to the diligent, creative farmers who survived wavering markets, changing tastes, Prohibition, and West Coast competition to grow a thriving New Jersey wine industry.

CONTENTS

ACKNOWLEDGMENTS

Most all of New Jersey's current wineries began their agricultural journey as either empty plots of land or rich produce crops and in some cases pastures for livestock. It is important to understand the early faces of what are now lush vineyards since winemaking is such a critical piece of New Jersey's economy and tourism. It stretches the imagination to look at a photograph of a dandelion crop or a field of grazing cattle and then sip a glass of chardonnay that grew out of that very same earth. I would like to thank all of the winemakers who took a break from pruning vines and crushing grapes to dig in their archives and family albums to provide the photographs for this book. For those wineries that are not represented here, because of lack of photography or archives, wine lovers will find you. I would also like to thank my husband Jay for tasting lots of wine, regardless of other responsibilities, and taking yet another journey with me.

INTRODUCTION

In all my travels and exploration of wine around the world, never did I grasp how difficult it is to coax the wine from vineyard to bottle. When I worked for a period of time with the modern Garden State Wine Growers Association, I gained insight as to just how difficult it is to produce one good grape harvest, no less hundreds and thousands of bottles of consistent, proper good wine is a long, intensive journey. And this was in 2007. Researching this book illuminated the long history of wine in the state of New Jersey, and also that human intuition and sweat equity more than 150 years ago was wildly impressive, considering what mechanisms were available to state farmers. Still today that sweat is expended year-round to make wine. That is the other thing I learned: winemaking is agriculture at its most primitive, no matter the decade.

Families are sustained from profits earned off of the land whether it yields vegetables or grapes for winemaking. New Jersey winemakers, for the most part, are farmers first. When they made the switch from other crops to wine grapes, all of them educated themselves through travel to mature wine-producing regions, books, seminars, and good old-fashioned trial and error. The knowledge of soil and weather by New Jersey winemakers is staggering. On many occasions I stood in a vineyard with a farmer who could look at a vine and tell me exactly when it would bear fruit. While the rows and rows of leafy, upward-growing plants might bear uncanny resemblance to each other, New Jersey winemakers can tell just what grapes to plant, and when, where, and how to nurture them. There are more than 200 varieties of grapes being grown in New Jersey, which are used alone or in blends to make some superior vintages. Many of the families depicted in this book were making wine in their basements or in barrels with Old World recipes as they farmed. They probably never knew that some day their land would actually earn a living for their descendants by making more and more sophisticated wine.

One of the charming things about New Jersey wineries is that many could pose as museums. They are stewards of past lives in agriculture, state history, and family lineage that extend far beyond state borders.

Today New Jersey natives and tourists consume the fifth largest amount of wine in the United States, and the more than 40 wineries creating hundreds of quality vintages each year make New Jersey the fifth largest wine producing state in the nation after California, Oregon, Washington, and New York. So why might the idea of a history of New Jersey wine come as a surprise?

There are several reasons for the relatively low profile of Jersey wines, some factual, some speculative. For one, American wine-producing states on the East Coast are dwarfed by the huge scale of production and marketing of California, Oregon, and Washington state wines. In an effort to transfer some of this West Coast-wine-making expertise to New Jersey, several

winemakers and consultants have come here from California. Many say that New Jersey is ripe (pardon the pun) for experimentation, because there is no preconceived notion of a New Jersey wine; thus there is much more room for creative freedom at the winemaker's hand.

Secondly, New Jersey is one of the few remaining states still attached at the hip to Prohibition (1920–1933) laws. Unfortunately some effects of the 18th Amendment to the Constitution outlawing the manufacture, transport, and sale of alcoholic beverages are still felt today, which greatly restricts the visibility of New Jersey wines (including no in-state shipping of wines), much to the chagrin of wine drinkers throughout the state.

Thirdly, the state's farmers simply have an abundance of agricultural talent that tends to be applied more toward the grape's cousins. New Jersey is ranked second in the nation for blueberry production, third for cranberry production, and fourth for peach production. For more than 100 years, farmers here have supplied fruits and vegetables to markets all over the mid-Atlantic, from New York City to as far north as Montreal. With all that other fruit in cultivation, the grape market seems less important. The Garden State tends to evoke thoughts of corn or other good things to eat, not drink.

Lastly, New Jersey has for decades battled an image problem. The good things about the state, such as its great wine country often get lost amid the airport, industries, and the shadow of New York.

As a result, New Jersey's thriving industry is lesser known to American wine consumers, but not for long. Newcomers to the industry, not depicted here because they are still planting, building, and bottling will infuse fresh life into the age-old art of winemaking. The New Jersey Office of Travel and Tourism is now working with the Garden State Wine Growers Association to ensure New Jersey winemaking gets its due. Consumers will soon learn about the regional diversity of wineries in New Jersey and that many wineries have produced national-award-winning vintages ranging from 2003 chardonnay to 2005 cabernet franc. Distinct viticultural areas such as the Outer Coastal Plains have secured coveted American Viticultural Area (AVA) designations.

New Jersey wineries are both curators of the past and champions of the future. The tenacity with which the farms in this book lived through changing markets and came back after Prohibition is impressive. The vigor with which new entrepreneurs are opening wineries is exhilarating. Learning a little more about this regional treasure might just compel the reader to visit the modern iterations of these pieces of our past. Cheers!

One

BEFORE THEY
WERE VINEYARDS

People who support themselves by wrangling nature and producing salable goods are brave, patient, and physically vigorous, for weather is not the only fickle agent involved in the toil of New Jersey agriculture. People's tastes change, economies fluctuate, and transportation evolves. Luckily the earth is equipped to change too, so soil can be manipulated to accommodate just about any crops. In New Jersey, farms are as varied as the counties in which they reside. From the sandy, loamy, France-like soil in southern New Jersey to the harsh, icy winter's frost trapped in the valleys of northern counties like Sussex and Hunterdon, the state has been producing an enormous variety of crops since it was settled.

Most of today's wineries were important leaders in the production and export of everything from dairy to Asian vegetables. Visit any of the currently operating wineries and remember that with the exception of Renault Winery in Atlantic County, which has been open continuously since 1864, all of the other wineries only began growing grapes within the last two decades. So the story behind the glass of wine begins with the grapes and the grapes are preceded by a wide lot of goods before them.

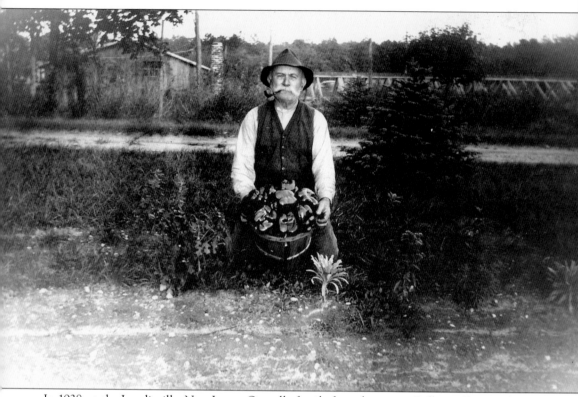

In 1938, at the Landisville, New Jersey, Quarella family farm, known as Bellview Farm and now Bellevue Winery, farmer Angelo Quarella proudly displays green peppers he grew for seeds. The patriarch of the Quarella family was honored by his grandson Jim Quarella, who retained the Bellview name when he converted the farm to a winery, Bellview Winery, after Angelo's hometown in Italy. Bellview originally began as a vegetable farm in 1918, planted by Angelo, an Italian immigrant. The farm would produce many different crops over the decades, including a long-yielding crop of Asian vegetables. It was after this specific market went global, forcing them out of the market that the Quarella family switched crops to wine grapes. (Courtesy Jim Quarella.)

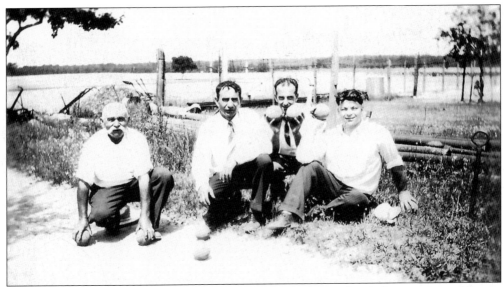

Angelo Quarella (left) and his cousins from Italy are taking a break from a game of Bocce, a traditional Italian game. They played on a dirt road beside farmer Quarella's front field in 1940. The field today grows merlot grapes, which thrive in the sandy soil and South Jersey heat. Three generations of the Quarella family still live on this land and give tours of the vineyards. (Courtesy Jim Quarella.)

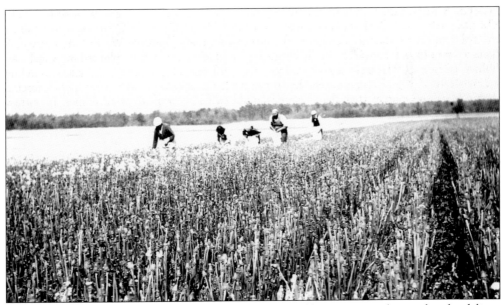

During the 1938 harvest in one of Bellview's many crop fields, migrant workers gather dandelions for seed, wine, and livestock feed. Today Bellview Winery is one of the few wineries in the country to produce dandelion wine. The dandelions have a short harvest period and the picking of the flowers remains a celebratory tradition each April. This field today grows Sangiovese wine grapes. (Courtesy Jim Quarella.)

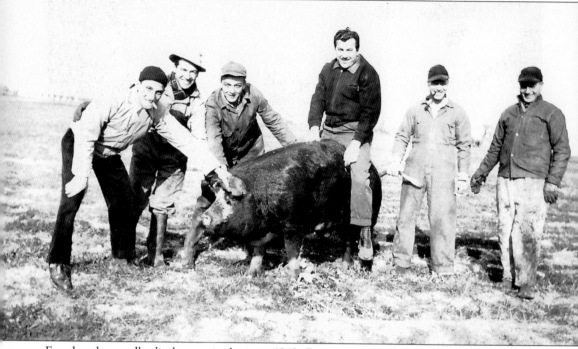

Farmhands proudly display a prized pig in 1942. Pigs were one of the original stock animals of Bellview Farms. In the early days of pig farming, the pigs were bred and fed lard, enabling the animals to grow to a staggering 500 pounds. This practice does not occur in modern pig farming. Since this was wartime, output and production on area farms was a critical source of employment and sustenance in the rural South Jersey area. (Courtesy Jim Quarella.)

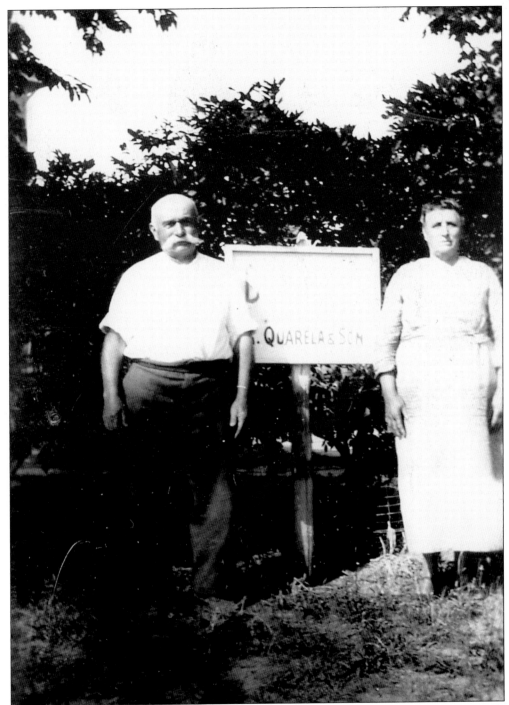

Angelo Quarella and wife Marie Quarella are seen outside of the original Bellview Farms, nearly 90 years before it was an operating winery. Angelo named his farm after his hometown in Italy, though its spelling was Americanized. Both husband and wife labored in the fields equally, raising their family in a farmhouse that today serves as the tasting and bottling room of the modern Bellview Winery. (Courtesy Jim Quarella.)

```
1809    Isaac Vanmeter,   Dr.

1810

March 27    by taking the acknowledgement
            on a deed                          $0.50

Aug 29      by cash paid Isaac Vanmeter
            and took his receipt in full        7.70
                                               11.20

sug.
Dec.        by four hundred bricks that
            I sent out by Aaron Crowell
            to Philadelphia for you.
            one barrel lime
            300 feet pine boards              $12.8

1811
Jan.        by cash for shoeing one of
            my horses                           1.12

June 17     by an order that you gave to
            Thomas Ross and me for $5.00        5.00

Nov. 23     by making coffin for your child    3.00
                                               21.97

            Cash paid to Mr. Edward, accord-
            ing to your bill                   $3.00

1812
Oct. 14     Cash paid you at my home and
            took your receipt in full           4.22
                                               4.22
                                                7.22

1813
Jan. 1      by cash at your home              $1.50

"    30     by my horse eight days and
            a half to go to Cumberland
            County in which you abused my
            horse in hard driving.
            $1.00 per day                       8.50
                                               10.00
```

Cape May County coffin maker Isaac Smith inhabited what is now the Cape May Winery. Page three of his accounting book shows the common practice of bartering. The winery produces a line of wines depicting Smith's house and the label is in the shape of a coffin. When the property was transferred to the current owners, a copy of "Isaac Smith's Book of Acts of Debt and Credit" was provided in the transaction. The pages are a true record of the way Cape May residents paid for their coffins, through credit, barter, and cash in the early 1800s. (Courtesy Toby Craig.)

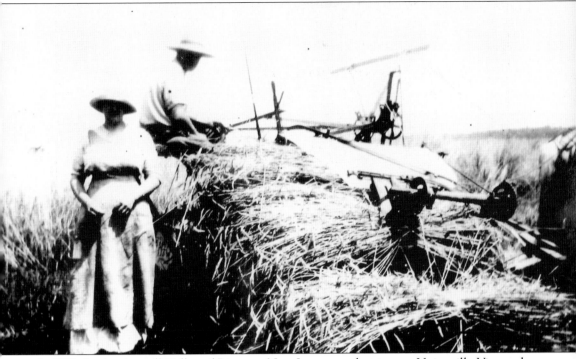

In 1910, in the Amwell Valley of Ringoes, New Jersey, at what is now Unionville Vineyards, workers take a rest from operating the sometimes unwieldy thresher, a farming device used to cut and pile grain. By the 1900s up through World War I, most all of the farms in the Amwell Valley had converted from fruit to dairy farms to meet the demands of the market. Unionville operated as such from 1900 to 1965. (Courtesy Unionville Vineyards.)

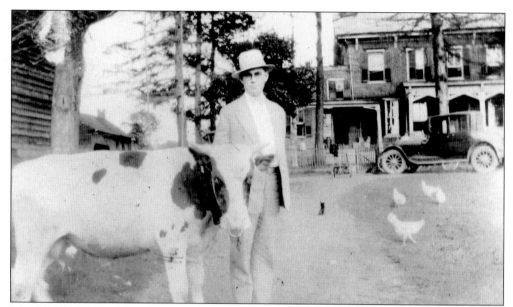

The Unionville land housed several homes over the centuries. It was first occupied in 1702, about three years after John Ringoes set up his trading post. Remains of Ringoes's cabin are still on the property and were occupied for nearly 100 years. A second home was built in 1800 where a garden now stands. (Courtesy Unionville Vineyards.)

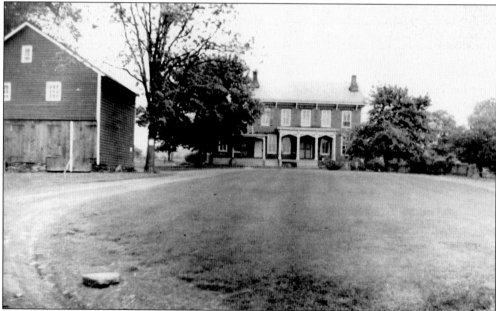

The third home, as it remains today, constructed between 1856 and 1858, is now part of the Unionville winery's tasting area. The original spruce and oak beams salvaged from the house were recycled to build the winery bar by hand. The original pegged mortise-and-tendon joints connect the hand-hewed post-and-beam structure and have been maintained throughout the winery building. All fieldstone used in the winery is from original foundations. The wishing well at the entrance is the original cistern used for livestock in the barn. (Courtesy Unionville Vineyards.)

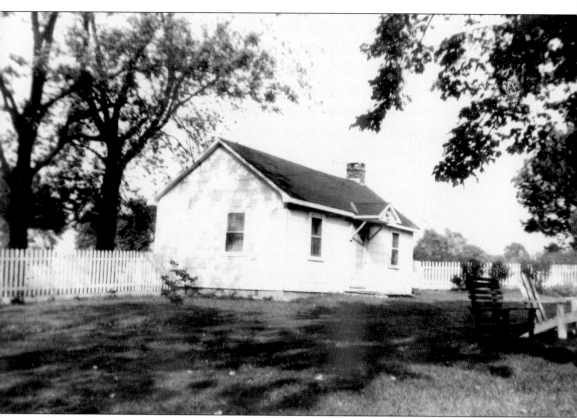

This cottage, built in 1947 to house farmhands and migrant workers, remains today on the Unionville Vineyards land. Its simple structure and design endured many changes in purpose over the years and remains today as a storage area for wine corks, bottles, and implements of modern winemaking. (Courtesy Unionville Vineyards.)

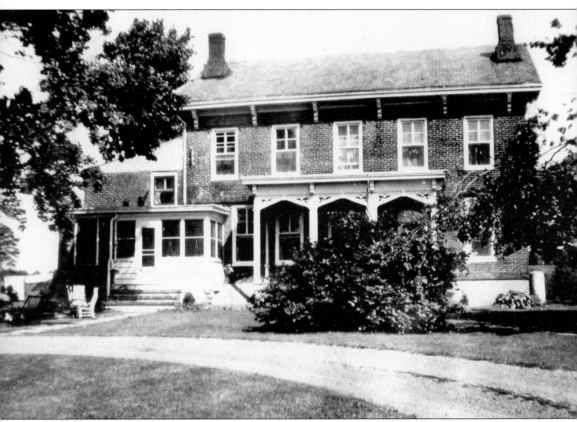

This is a front view of the original main house. Today this house stands very much as it was then. It is now adjacent to the modern-day wine tasting room and overlooks the bottling facility at Unionville Vineyards. The current owners live in this house part time. (Courtesy Unionville Vineyards.)

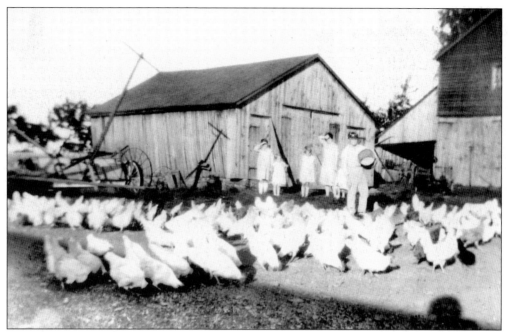

In 1925, a double corn crib was a key piece of farming equipment. Working tenants of the thriving dairy farm tend to the chickens. Dressed in white socks, the five girls and mother help out on the farm, unbothered by the mess that surrounds them. Whole families survived the Depression by living on and tending to other's farms. (Courtesy Unionville Vineyards.)

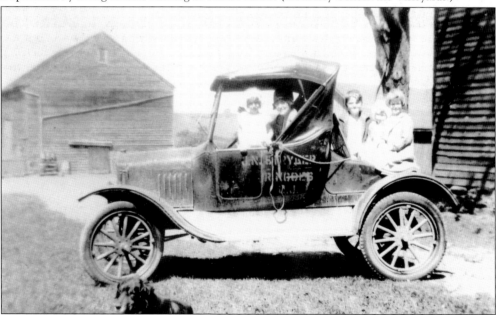

The novelty of a car is evident in the girls' smiles. They are pictured here in the driveway, which remains today at the modern Unionville Vineyard. These children would have enjoyed a comfortable farm life, as during this time of 1913, their town of Ringoes was home to the headquarters of Black River and Western Railroads, enabling their families' products to be easily shipped all over the country, increasing their wealth. (Courtesy Unionville Vineyards.)

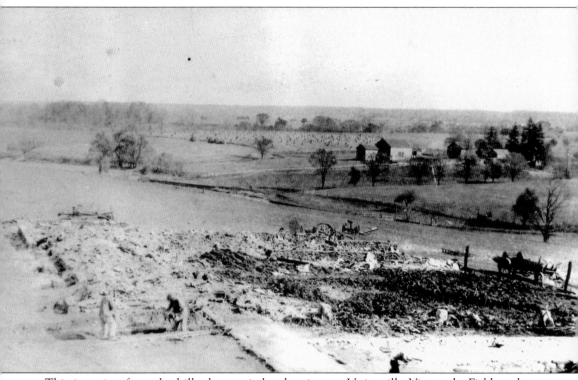

This is a view from the hills that encircle what is now Unionville Vineyards. Field workers prepared soil for planting by hand and were often at the mercy of harsh northern New Jersey weather. Today these fields are lushly planted with pinot grigio, which benefit from the valley created by the surrounding hills. (Courtesy Unionville Vineyards.)

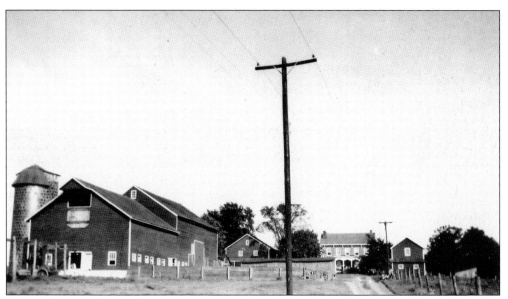

A view from the dirt road looking up into the dairy barns is seen here. Today this road remains much the same and the land that surrounds it is fairly untouched. The silos are gone, replaced by low-laying wine storage areas that house stainless steel and wooden casks for fermenting wine. (Courtesy Unionville Vineyards.)

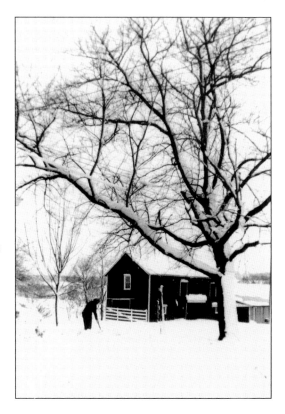

In 1950, the farm was transitioning successfully to dairy farming. This winter scene is a reminder of the harsh weather that challenged area farmers. The moneyed families who owned this land over the years invested well. In 1856, while operating as the largest peach orchard in the country, 100 acres were split off and given as a dowry present when one of the farmer's daughters married into the wealthy New York City Blackwell family. They owned Blackwell Island, which existed as a leper colony for a time. The addition of the Blackwell's wealth to the peach farm only increased its success. (Courtesy Unionville Vineyards.)

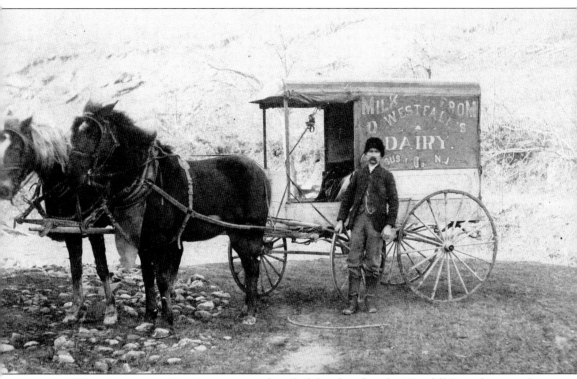

In 1873, in Montague, New Jersey, an unidentified farmhand at the Westfall Farm leans on his dairy truck. According to the original deed, Simon Westfall purchased the land for Westfall Farm from the Earl of Perth in 1774. The lawyer who handled the transaction, Elias Boudinot, would later serve as a delegate to the Continental Congress and sign the Treaty of Paris. Westfall built the original stone house and farmed the tract of land. The American Revolution broke out in 1775, and Westfall Farm was suddenly thrust onto the front lines as Joseph Brant and his Tories conducted raids in neighboring Port Jervis, New York. The farm survived the Revolution, and beginning in the early 19th century, Westfall Farm became a stop on the Underground Railroad for run-away slaves looking for freedom in the north. (Courtesy Westfall Winery.)

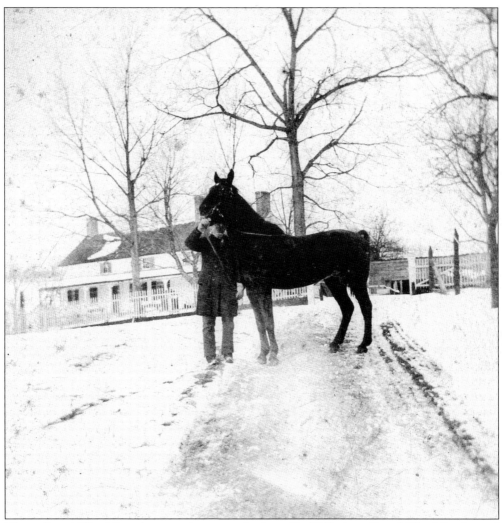

This is David Westfall and a young horse on the farm. Dr. Wilhelmus David Westfall inherited the farm from his grandfather David, who inherited it from his father and cultivated an array of successful enterprises on the farm, including lumber, produce, and dairy, up until his death in 1916. Dr. Westfall, a professor of mathematics at the University of Missouri, was better suited to academia than to the science of farming. Wanting to keep the farm in the family, he leased it to tenants who worked the land up through the Depression while he remained in Missouri. Westfall Farms today is coincidentally part-owned by another academic, Georgine Mortimer, who holds a doctorate in chemistry. (Courtesy Westfall Winery.)

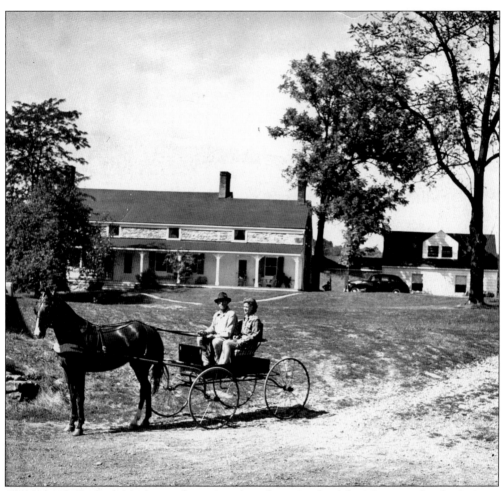

Charles and Elizabeth Mortimer, the patriarch and matriarch of the Mortimer family, are seen on the original Westfall farmland. In 1942, Charles installed indoor plumbing, expanded the main barn complex to accommodate the growing dairy herd, and constructed new buildings to make Westfall a state-of-the-art dairy producer for its time. Perhaps the years of natural fertilizer made the transition from dairy to viticulture smoother. Charles still resides on the land and runs a winemaking class out of the winery. (Courtesy Westfall Winery.)

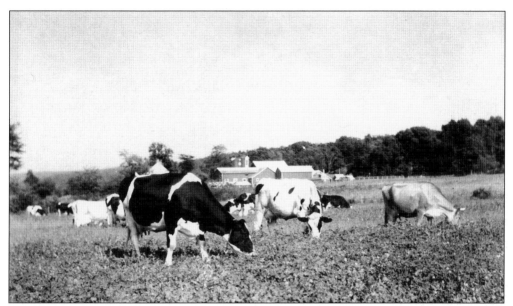

Cattle graze in a pasture that is now planted with varieties of Italian grapes, including Sangiovese. In 1940, after 166 years in the family, Dr. Wilhelmus David Westfall sold the property to Charles G. Mortimer Sr., and so began a new chapter in Westfall Farm's history. Mortimer, a prominent business leader in advertising, knew the Westfall name was a commodity and decided to keep it. (Courtesy Westfall Winery.)

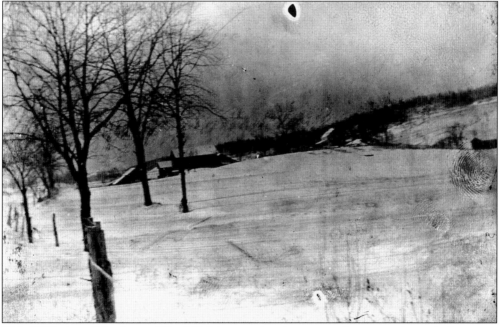

This 1888 view of the former Westfall dairy remains the same today, except instead of pastures there are three acres of merlot grapes. This space was often the scene of fierce snow as Westfall is located in the northernmost area of the state of New Jersey. Winters were notoriously brutal, hosting a strong north wind. Today the vineyards are among the first in New Jersey to be harvested, due to the early frosts. (Courtesy Westfall Winery.)

The 1940s and 1950s were a time for Westfall Farm to produce a thriving dairy business. In records kept by the Mortimer family they note, "The die is cast. We have lined up 25 black and white beauties. All are bred heifers and line-bred 45th stock. What a lucky break—to start with a line-bred herd it would take otherwise ten or more years to breed! And best of all, they cost enough less than the budget to insure our fat test." The farm was one of the most prosperous in Sussex County, and upon this area of the 378 acres of Westfall land, cows earned the reputation for the best buttermilk production. The *Sussex County Independent* carried a news story about three of Westfall's "500-lb fat cows" and how they led the state in quality. (Courtesy Westfall Winery.)

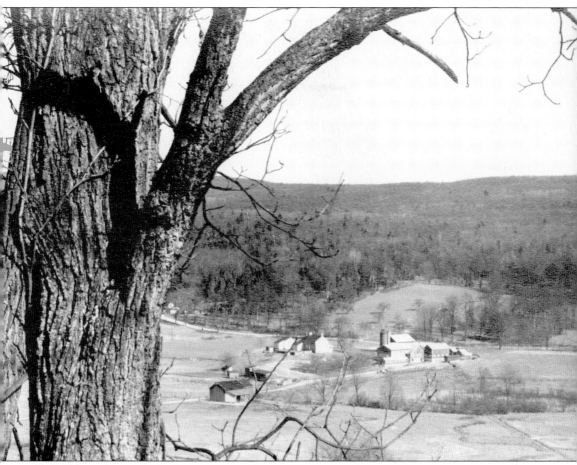

This is a view from the hilltop at Westfall Farm. It was here in 1942 that the Westfall family finally appraised the herd of cattle they were breeding and realized it was worth four times what the family had guessed. The herds that grazed around these fields gained the perfect amount of weight that later made the Westfall Holstein herd famous for its meat. The hills around the farm create a bowl effect that captures the fog and frost, which actually benefits the land's new life as a vineyard. The valley is now planted with a several varieties of grapes, which are of the hardiest varieties in order to endure the weather. (Courtesy Westfall Winery.)

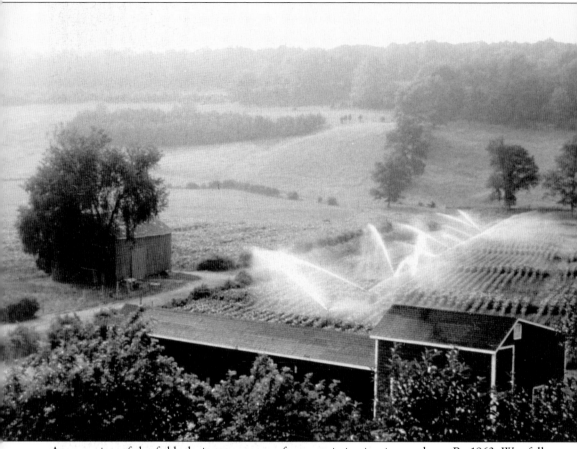

An overview of the fields during a summer afternoon irrigation is seen here. By 1963, Westfall Farms's cattle herd had attained many records for milk production by the Holsteins, including the world record for butterfat production. The mid-1960s, however, would signal an end to the successful dairy production, as labor became scarcer and "good dairymen" as Charles Mortimer wrote in his journal, "are no longer top-drawer and don't stick around long." By 1966, the entire farm was converted to a horse farm, and part of the land remains so today. (Courtesy Westfall Winery.)

In 1993, the land in Wantage, New Jersey, was wild before it was cleared to make room for planting grapevines at Ventimiglia Vineyards. These parcels were being held for years by a developer with the hopes of building 30 homes on the Sussex County property. Instead, it was purchased by the Ventimiglia family in 1994. The first bottling of four different wines took place in 2005. (Courtesy Ventimiglia Vineyards.)

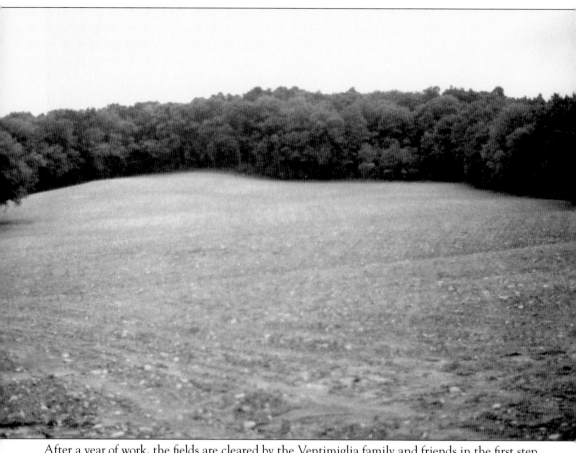

After a year of work, the fields are cleared by the Ventimiglia family and friends in the first step toward building a modern vineyard. Cold temperatures in this northernmost portion of the state slowed down the project on several occasions. (Courtesy Ventimiglia Vineyards.)

The Ventimiglia family turns the land first into fields of corn and alfalfa to prepare the soil for grapevines. The new crops quickly adapt to the temperatures giving hope to the would-be vintners. (Courtesy Ventimiglia Vineyards.)

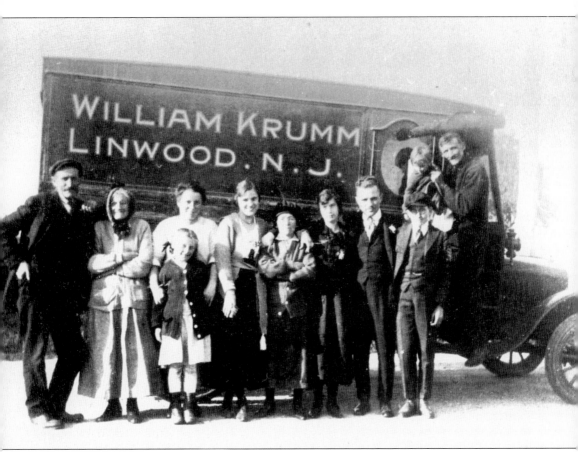

In 1914, the Krumm family is seen with the truck they used to transport their produce to local markets in Linwood, New Jersey, and the surrounding areas. Three generations of the Krumm family of German immigrants tended crops, which included corn and lima beans. The thriving family farm eventually turned portions of its 50 acres of land into grape vineyards. Rapid residential growth occurred all around the farm, yet the hardy Krumms prevailed, operating up until 1975. (Courtesy Krumm family.)

Two

MAKING WINE BY HAND AND MACHINE

To visit a winery is to understand the enormous task it is to make just one bottle of wine. From the massive production of cultivating the land in order to plant vines (and in many cases in New Jersey, to convert the soil from one crop to another) to battling the elements, it is a bit of a miracle that a grape turns into a glass of wine at all.

Many of the methods employed by late-18th-century and early-19th-century winemakers are still used today. New Jersey is unlike the larger winemaking states, in that nearly all of the wineries operated then and now are under the watchful eyes of families, and are not corporate entities with massive staffs.

Some of New Jersey's wineries have hired winemakers away from the Napa Valley, clearly an indication of the growing excitement about the Garden State's wine industry. Most all wineries in New Jersey have surprisingly small and tidy production areas. Each has a laboratory in which the winemaker experiments with the necessary chemistry to make wine. Each has a collection of wooden casks, either French, Hungarian, or American oak. All employ a peculiar tool called a wine thief, which is an elongated hollow tube of sorts that a winemaker uses to siphon out wine to taste as it ages. It gets its name from the obvious pleasure the winemaker gleans from his "chore" of tasting—or stealing—a bit of wine each day. Each winemaker then and now has their own recipes and tricks for making wine. Some who adhere to the small-batch blending of wine, per French standards, might add an egg white to an aging barrel of red wine. Any gases or excess chemicals will adhere to the white, weighing it down, so that the bad stuff settles at the bottom of the barrel and the good wine may age cleanly. Others add clay to their barrels, so that it will absorb through its porous body, the extra dirt and sediment that may be in the barrel.

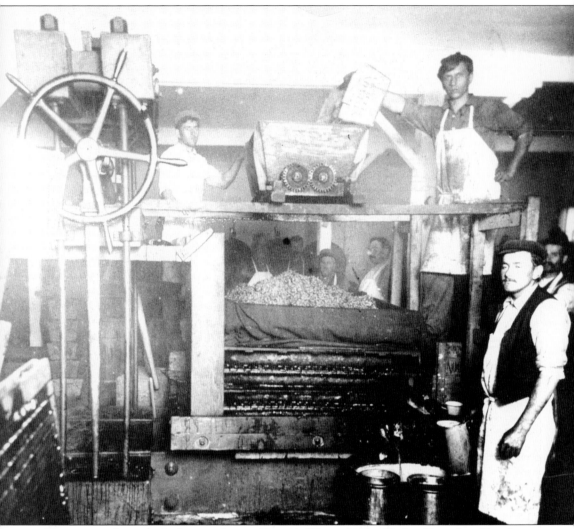

This is an early method of winemaking at Renault Winery in Egg Harbor Township, New Jersey. Opened in 1864, Renault Winery remains the nation's second oldest continuously operating winery. Workers in the winemaking room operate a hand-driven wine press. This enormous manual machine performed the delicate process of separating grapes from their stems and skins. A messy process for the men, their own skin was often irreparably stained from the red grapes. It was not uncommon for them to walk around on rare days off with purple fingers. (Courtesy Renault Winery.)

8/21/34.

Sherry Wine 14%

to be added to each gallon:

0.5 Gm. Citric Acid (for 1000 gals
0.1 Gm. Tannic Acid 500 Gms
7 Gms. Sugar (not enough) 100 Gms
0.6 Gm. Potassium Bisulphite 7000 Gms
 Water 600 Gms
(Dr. Blackhurst) Wine

Potassium Bisulphite — 3 Gms in 50 gals of Wine

9/14/34.

Sherry Wine 14% w 13.9% Per gal.

as follows:

Wine Sherry approx.	750	gals.	
Water	386	gals.	
Sugar	155	lbs.	.1364
Citric Acid	500	Gms.	.4401
Tannic Acid	100	Gms.	.0882
Potassium Bisulphite	600	Gms.	.528

9/14/34.

Port Wine Per gal.

Port Wine approx	650	gals.	
Water	200	gals.	
Sugar	100	lbs.	.117
Pot. Bisulphite	600	Gms	.706

Vermouth

40% Angelica
40% Muscatel } Wine
20% Coloring Sol as follows :

{
.50 Gms. Sugar
1 Gm. Caramel
10 min. Glycerin
1000 c.c. q.s. Water
}

4.5 c.c. Vermouth Extract

The hand-written recipes of one of Renault Winery's original winemakers date back to 1930. This page displays the complex mixture of acids, sugars, chemicals, water, and wine that are needed to make alcohols in their many iterations. Here are the recipes for sherry wine, port wine, and vermouth. Many of these recipes are the basis upon which Renault's current winemaker creates the line of modern wines. (Courtesy Renault Winery.)

Orange Bitters (100 gals.)

11/12/36.
Caffeine — 4 lbs. 9 oz.
Phenolphthalein — 7.3 oz.
Sod. Glycerophosphate Crystals. — 22.85 lbs.
Saccharin — 1 oz.
Alcohol — 49 gals.
Water — 50 gals.
Fresh Orange Peel — 29 lbs.

Alcohol — 44.85%
Coloring — 19 c.c.

1/22/37. Orange Bitters (300 gals.)
Caffeine — 13.8 lbs.
Phenolphthalein — 1.38 lbs.
Sod. Glycerophosphate Crystals — 68.5 lbs.
Saccharin — 3 oz.
Alcohol (including alcohol on Peel) — 148 gals.
Water — 150 gals.
Fresh Orange Peel — 100 lbs.

Alcohol — 44.85%
Coloring Sol — 55 c.c.

5/3/51. Orange Bitters (150 gals.)
Caffeine — 6.9 lbs.
Phenolphthalein — .69 lbs.
Sod. Glycerophosphate (crystals) — 34.25 lbs.
Saccharin — 1.5 oz
Alcohol — 74 gals.
Water — 75 gals.
Fresh Orange Peel — 50 lbs.

Alcohol — 44.65%
Coloring Sol. — 25 c.c.

Seen here is one hand-written recipe for orange bitters. Often recipes were tinkered with and revised dozens of times to perfect the taste and often the alcohol level, which was critical to the beverage's classification. Wines, ports, aperitifs, and other spirits contain varying alcohol levels, which are controlled by sugar and the fermentation process. Interestingly, these recipes call for the addition of caffeine. (Courtesy Renault Winery.)

6/21/37. Orange Bitters (300 Gals.)
 Caffeine 13.8 lbs.
 Phenolphthalein 1.38 lbs.
 Sod. Glycerophosphate Crystals 68.5 lbs.
 Saccharin 3 oz.
 Alcohol 148 Gals.
 Water 150 Gals.
 Fresh Orange Peel 100 lbs.

 Alcohol ~ 44.870 D
 Coloring Sol ~ 50 c.c.

6/21/37. Orange Bitters (25 Gals.)
 Caffeine 1 lb. 2 oz.
 Phenolphthalein 1.8 oz.
 Sod. Glycerophosphate Crystals 5.71 lbs.
 Saccharin 7 grns.
 Alcohol 12.5 Gals.
 Water 12.5 Gals.
 Fresh Orange Peel

 Alcohol ~ 44.870 D
 Coloring Sol.

9/22/37. Orange Bitters (300 Gals.)
 Caffeine 13.8 lbs.
 Phenolphthalein 1.38 lbs.
 Sod. Glycerophosphate Crystals 68.5 lbs.
 Saccharin 3 oz.
 Alcohol 148 Gals.
 Water 150 Gals.
 Fresh Orange Peel 100 lbs.

 Alcohol ~ 4570 D
 Coloring Sol ~ 50 c.c.

Pictured here is another recipe variation for orange bitters. (Courtesy Renault Winery.)

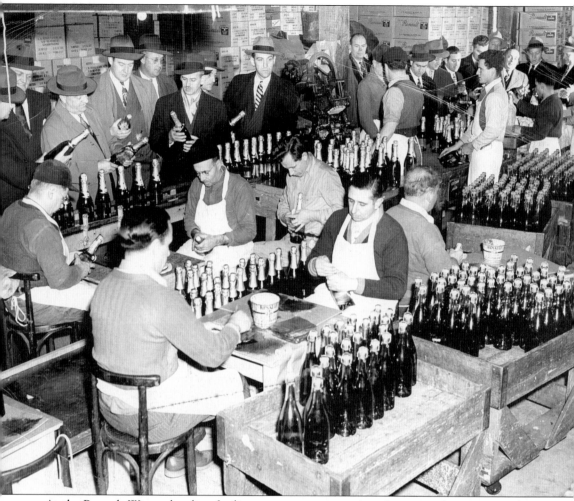

At the Renault Winery bottling facility space was at a premium. In cramped quarters, workers prepare Renault's popular champagne as Renault sales representatives look on. The men visited the assembly line often, to taste new vintages and pick up cases to distribute to anxious buyers. Each champagne bottle was hand wrapped in its celebratory signature gold foil. (Courtesy Renault Winery.)

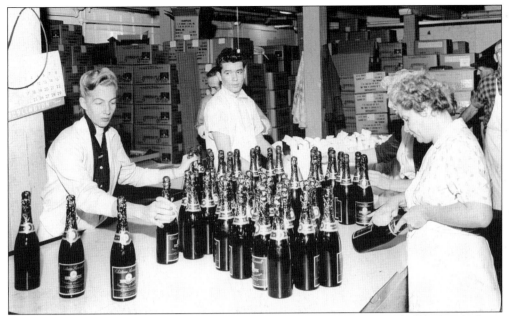

This is one of the many champagne preparation tables. Each bottle was washed by hand after it had gone through the line. After the women washed off any external sediment the bottles were passed down to be wrapped in festive paper. Bottle facilities then, and today, are often pristine production areas in order to cut down on bacteria that can ruin wine. Most likely the step depicted here was an extra precaution. (Courtesy Renault Winery.)

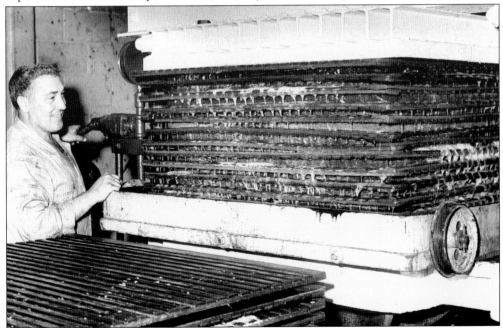

Vincenzo Alverio is the nephew of one of Renault's original owners, Maria Alverio. The hand-operated wine press remains in the winery's press room today, as it is still an effective means of separating the grape pulp from certain wine grape skins. Vincenzo also crafted all of the still-remaining woodwork in the original winery. (Courtesy Renault Winery.)

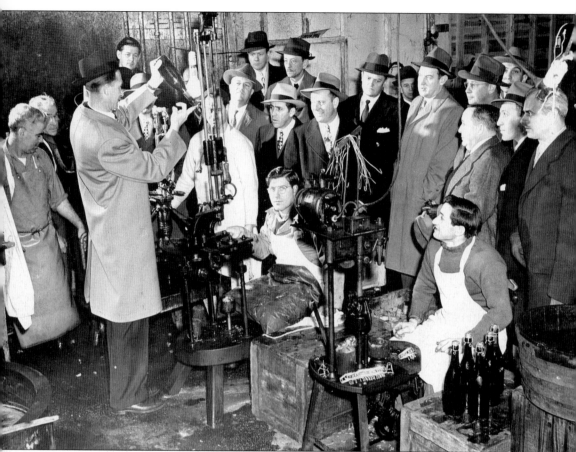

Renault Champagne sales representative Ed Garinger demonstrates how to remove the sediment that gathers in a champagne bottle as a result of a double fermentation process. This is achieved when the bottle rests for a year or more, tilted downward on a riddling rack, thus making the liquid fill the space before the cork. This liquid is then frozen with dry ice and then salted with brine, to remove the undrinkable portion in the neck. This method is still used today with Renault's premium champagne. (Courtesy Renault Winery.)

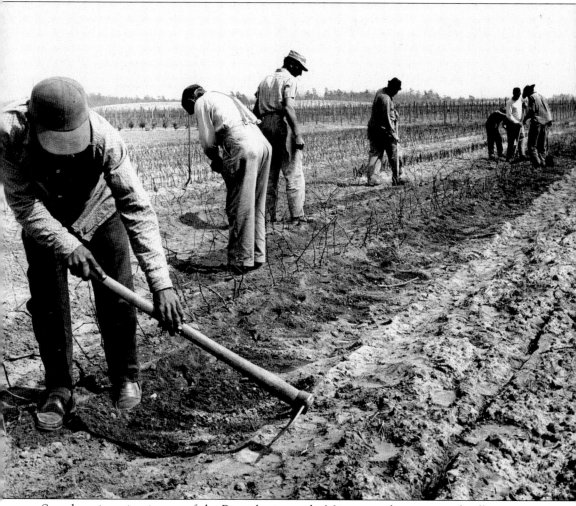

Seen here is a view in one of the Renault vineyards. Migrant workers were and still remain a critical part of the labor-intensive winemaking process. Before modern soil cultivation machines, hundreds of hours of manual labor were required to prepare and maintain the vineyards. At this time and even up through the present day, southern New Jersey wineries are in constant battle with bugs, heat, and the sandy, loamy soil that must be irrigated quite precisely in order to yield the best crop. Modern Renault manager David DeMarsisco adheres to organic insect control. (Courtesy Renault Winery.)

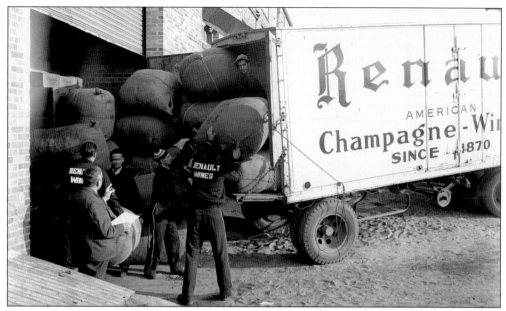

Workers at the loading dock at Renault Winery unload large, heavy bags of yeast. These will be used to ferment the varieties of wine produced over a period of months. Many winemakers have secret formulas of yeast mixtures that enable them to produce unique tastes and differing alcohol contents. Renault was a steady employer in the sometimes depressed area of south New Jersey. At times, the winery employed anywhere from 50 year-round employees to its 250 staff members today. (Courtesy Renault Winery.)

As seen between two large wooden wine casks, workers at Renault Winery pass baskets of grapes through the door into the processing room. The grapes were handpicked each fall and put into hundreds of baskets. This is primarily the way grapes are harvested today in New Jersey vineyards. Many seasonal workers return each year to harvest the grapes. It is a time of great celebration, as the crop has survived the winter and soon will be transformed into wine. (Courtesy Renault Winery.)

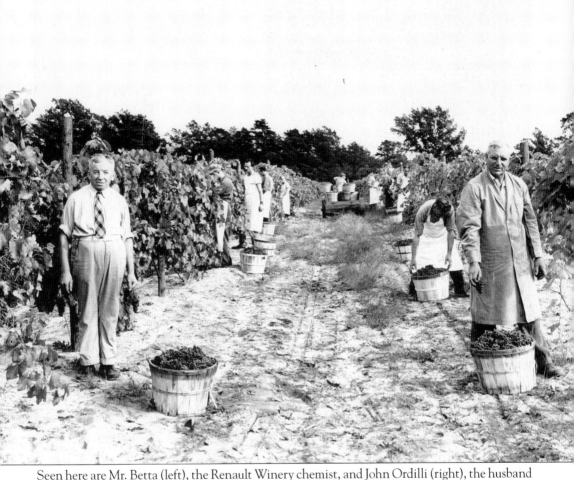

Seen here are Mr. Betta (left), the Renault Winery chemist, and John Ordilli (right), the husband of Santa D'Augustino, a member of the second family to own Renault Winery. In 1938, the men are working in the vineyard alongside migrant workers to pick the harvest. An important factor in the winemaking process is the chemist. At the Egg Harbor winery, the chemists then and today have their own laboratory. They often are seen in the fields though, checking the grapes on the vines to determine their readiness for harvest. (Courtesy Renault Winery.)

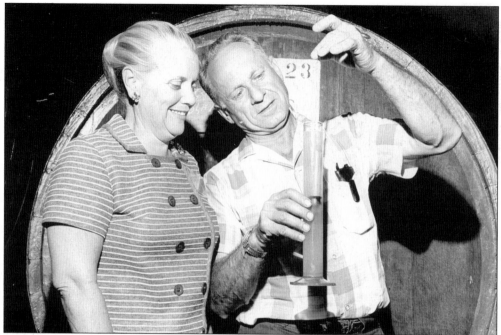

Renault winemaker John Ordille shows Mrs. Eugene DeMartin, a visitor in 1952 to the winery from Hohokus, the process of using a hydrometer to check on the chemical properties of wine as it ferments in the barrel. Winemakers spent much of their time checking on wine quality and progress using a range of chemicals, yeasts, and wine blends and were often tinkering in barrels to ensure proper taste. This is still true today. (Courtesy Renault Winery.)

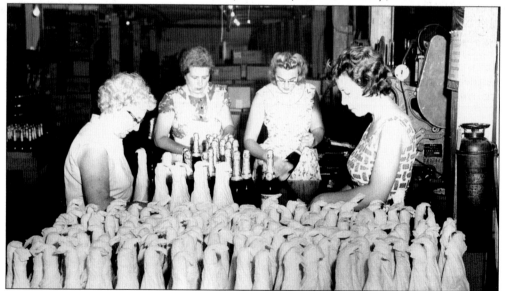

Four women employees of the winery work on the bottling line to package Renault Winery's Dumont brand of champagne. Each bottle had to be inserted into a wire cork spinner at the top, then the bottle's neck was capped in shiny colored foil, and then the whole bottle was wrapped in colorful tissue for shipping to stores and consumers. All of this was done by hand. (Courtesy Renault Winery.)

This is a hand-illustrated wine label from Renault Winery. Labels were often hand-drawn and then delivered to a printer in Philadelphia who would create a custom metal plate to manufacture huge shipments of paper labels. (Courtesy Renault Winery.)

Renault

NEW JERSEY STATE

BLUEBERRY DUCK (REG.)

NATURALLY FERMENTED

New Jersey State Champagne, Bulk Process Sparkling Wine, New Jersey State Sparkling Burgundy with Blueberry and Other Natural Flavors Added

PRODUCED & BOTTLED BY

Renault Winery Inc.

Wine labels were hand-applied by workers at Renault. Some of these labels are being resurrected today to reflect a respect for the traditions that endure, although labels are now applied by a machine. (Courtesy Renault Winery.)

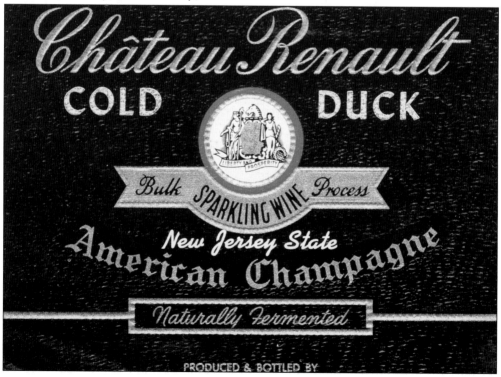

These hand-illustrated labels reflect the range of wines bottled by the prodigious Renault Winery. Renault and many modern wineries will hire artists to illustrate labels for certain premium wines. (Courtesy Renault Winery.)

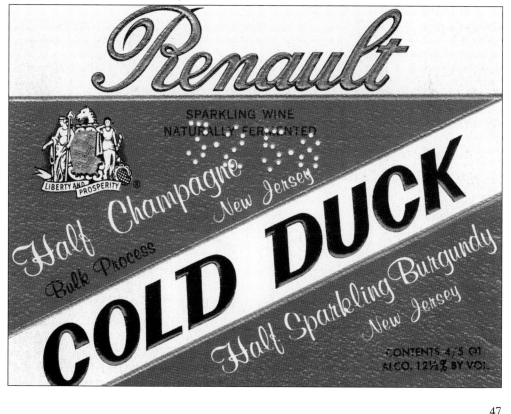

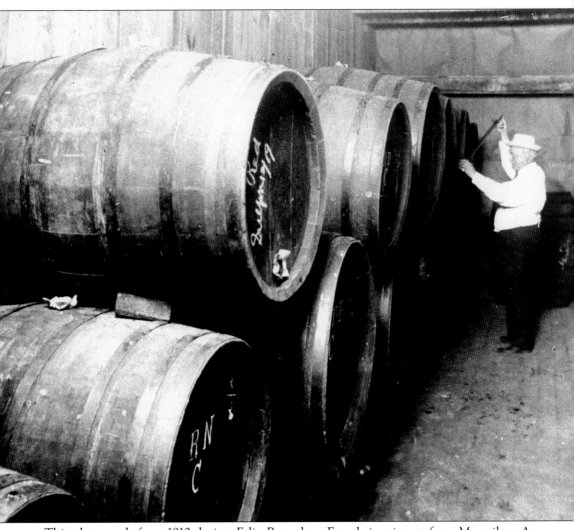

This photograph from 1910 depicts Felix Renault, a French immigrant from Mareuil-sur-Ay, France, the original founder of the second oldest continuously operating winery in the United States, using his wine thief. These long glass devices are coveted today and antique versions are difficult to find. A wine thief is used to manually suck up a bit of wine out of the top of a barrel so that the winemaker can taste its progress. It gets its name because the portion extracted makes its way into the belly of the winemaker and robs the barrel of some of its bounty. (Courtesy Renault Winery.)

TELEPHONES,
 KEYSTONE
 BELL

WAREHOUSES,
 1214-16-18 KATER STREE
 713 TO 23 S. WATTS ST.

J. BLOOM & SONS

WHOLESALE

BOTTLE DEALERS

OFFICE, 1211-13 BAINBRIDGE STREET

PHILADELPHIA. PA.

REPRESENTED BY..

A business card of J. Bloom and Sons, a prominent dealer of bottles, is seen here. In the 1940s, there were many players in the process of making wine. From the farmers in the field to the workers on the bottling line, the process was one of multiple steps and products needed to make just one bottle of wine. At that time, it was less expensive for the south New Jersey–based Renault Winery to drive to Philadelphia to meet with bottle manufacturers or for the salesmen to call on the winery. (Courtesy Renault Winery.)

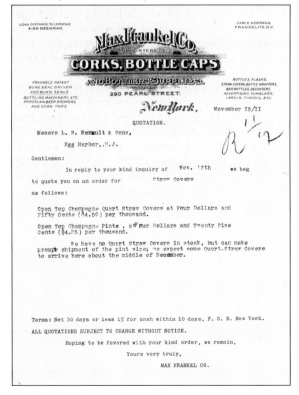

WINE, LIQUOR & DISTILLERY WORKERS UNION, LOCAL ONE, AFL–CIO

1860 Broadway, New York 23, N. Y.

APPLICATION FOR MEMBERSHIP — ▮▮▮▮▮ EMPLOYEES DIVISION

I_____now employed
(Print Your Name)

by_____
(Name of Firm)

of_____
(Address of Firm, Town, City & State)

I do hereby designate and authorize the WINE, LIQUOR & DISTILLERY WORKERS UNION, LOCAL ONE, its affiliates and its representatives, to act exclusively as my agent and representative for the purpose of collective bargaining, and for the presentation, adjustment and settlement of all grievances against my employer, and all other matters relating to terms and conditions of employment or arising out of the employer-employee relationship.

| Type of Work | Signature | Date Signed |

| Date Employment Started | Home Address | |

| Present Weekly Salary | City | Zone | State |

Seen here is a 1940 membership card for the wine, liquor and distillery workers union, Local One, AFL-CIO. By this time in the liquor industry, workers had formed a union. Its purpose was stated as designating the union to represent workers for the purpose of collective bargaining and for the presentation, adjustment, and settlement of all grievances against employers and all other matters relating to terms of employment, conditions, and relationships with employers. (Courtesy Renault Winery.)

In 1911, a letter arrived from the Max Frankel Company to the Renault family providing a price quote for champagne supplies. The New York City company offered a price of $4.50 for 1,000 straw champagne covers and $4.25 per 1,000 for open-top champagne pints, which were green glass bottles used for the winery's popular champagne. In the early days before Prohibition, distributors of liquor supplies were prosperous. Max Frankel also sold decanters, advertising tumblers, flasks, labels, and tin foil. (Courtesy Renault Winery.)

Three

CREATIVE WAYS TO SURVIVE PROHIBITION

Today it is hard to imagine a ban on the purchase of alcohol nationwide. Certainly there are still dry towns in the country and many in New Jersey. The case of the 18th Amendment and its subsequent repeal illustrates the cyclical nature with which American vices go in and out of fashion. Although most Americans are free to purchase wine when they would like, the advertising of wine, champagne, and other spirits has become more regulated. Those who grew up in the 1970s should remember a much larger presence of billboard, magazine, and even television advertisements for alcoholic beverages. Changes in advertising laws and liquor control rules diminished the preponderance of this type of promotion over the years.

Before the modern rules of promotion, winemakers regularly advertised their products, and in the case of Renault Winery, they routinely partnered with other enterprises like the Miss America pageant to enhance their visibility. During Prohibition, the few wineries that were able to remain open did so by essentially switching labels and altering the alcohol content. By increasing to a whopping 22 percent, wine became "tonic." Renaming it tonic positioned it to consumers who ostensibly now benefited, not enjoyed, wine as it was suddenly sold at pharmacies. It is also not a stretch of the imagination to consider that some wineries had connections to liquor control employees and somehow skirted the more rigid Prohibition rules.

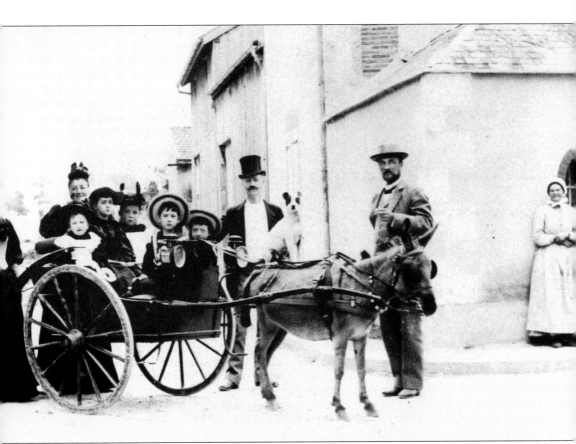

Louis Nicholas Renault and his family are seen here in Mareuil-sur-Ay, France. Renault Winery founder Louis Nicholas Renault was born in Mareuil-sur-Ay in the Champagne region of France on April 2, 1822. The son and grandson of French barrel makers for the champagne trade, Renault grew up in the business. When the vociferous phalaxer parasite descended upon French vineyards causing a temporary hole in French winemaking in 1862, Renault decided to bring his talents to the United States. His deep knowledge quickly earned him success as a wine and champagne salesman for a series of large importers. At the time, the very thought of American champagne did not exist. Although wine was being made in America, European vintages were thought to be the only drinkable and marketable wines. Renault brought some vinifera he had cultivated in France, which he knew he could successfully plant in southern New Jersey's soil that was and remains quite similar to that in France. (Courtesy Renault Winery.)

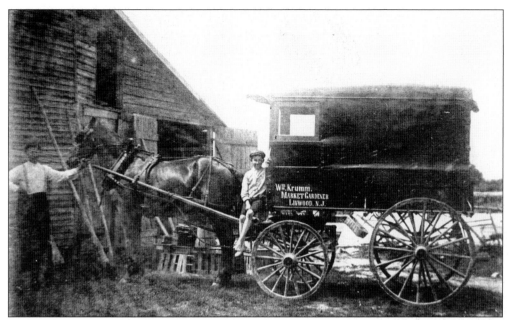

Within the 50 acres of the thriving corn and lima bean crop this German immigrant family grew, they also cultivated one of the area's only other wine grape crops. In 1912, John George William Krumm built the Krumm Winery in Linwood. Krumm did everything by hand, but faced many challenges over the years. The winery survived Prohibition by producing wine jellies, tonic, and cooking wine and sherry, products allowed by the Volstead Act of 1920. Krumm operated as a winery until 1975. The former vineyard still stands in the middle of suburban Linwood and is inhabited by the surviving Krumm family members. (Courtesy Krumm family.)

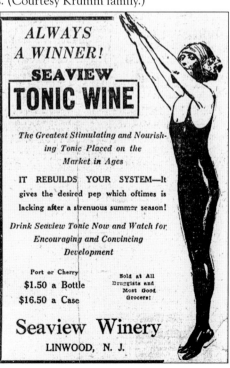

ALWAYS A WINNER!

SEAVIEW

TONIC WINE

The Greatest Stimulating and Nourishing Tonic Placed on the Market in Ages

IT REBUILDS YOUR SYSTEM—It gives the desired pep which oftimes is lacking after a strenuous summer season!

Drink Seaview Tonic Now and Watch for Encouraging and Convincing Development

Port or Cherry

$1.50 a Bottle

$16.50 a Case

Sold at All Druggists and Most Good Grocers!

Seaview Winery

LINWOOD, N. J.

This is an advertisement from the 1920s for Krumm Winery's Seaview Tonic, one of the products that enabled them to remain operational during Prohibition. Because of the ban on alcohol, consumers were eager to purchase anything with wine in it. Wineries who were able to survive the restrictions of Prohibition cultivated close relationships with pharmacies, or druggists, so that they would promote wines as health tonic, many of which, ironically, contained far more alcohol than their traditional distilling recipes. (Courtesy Krumm family.)

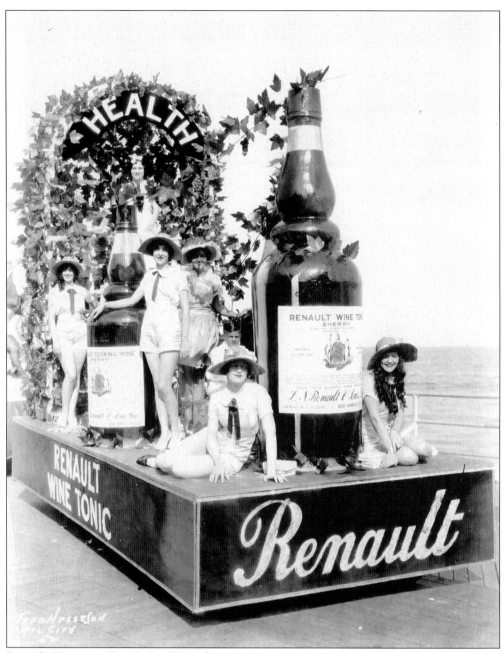

Renault Winery in Egg Harbor Township was one of two known wineries in the state of New Jersey to survive the restrictions of Prohibition. With some shady connections in the powerful center of Atlantic City politics, then owner John D'Augustino was able to secure a permit to continue operating his winery under the auspices of producing wine for usage as a health tonic or as cooking sherry. The "health tonic" was a runaway best seller. This promotional float advertises Renault's Wine Tonic. Perhaps one of the most appealing aspects of the popular notion was its unprecedented alcohol content. It was sold in pharmacies all across the nation through Prohibition, and doctors prescribed it to patients liberally for maladies ranging from pregnancy pains to insomnia. (Courtesy Renault Winery.)

1855 1930

Official Souvenir
and PROGRAM of EVENTS

Diamond Jubilee Celebration

April 25 - 26 - 27 Incl.

EGG HARBOR CITY

Its Past and Present

Sponsored by
RUDOLPH ELMER POST, No. 158
AMERICAN LEGION

Price 35c

Pictured here is the cover of *Egg Harbor City: Its Past and Present,* the official souvenir and program of events for the Egg Harbor Township diamond jubilee celebration in 1930. Renault Winery was a long-term member of Egg Harbor's business community and well respected. (Courtesy Renault Winery.)

LINKING
A
FRIENDSHIP
A
LOYALTY
And an
ADMIRATION

One of Egg Harbor's oldest firms felicitates the City of Egg Harbor upon its 75th birthday

L. N. Renault & Sons, Inc.

began making Wines and Champagnes here in 1870. Since that period the name RENAULT has been associated with Egg Harbor City for sixty years, first with Wines and Champagnes and now with Medicinal Wines, Wine Tonics, Brandied Fruits, Wine Jellies and Wine Syrups.

L. N. Renault and Sons, Inc.
ESTABLISHED 1870
EGG HARBOR CITY

This is a Renault Winery advertisement that appeared in the Egg Harbor Township diamond jubilee celebration's program. The winery consistently partnered with local businesses to boost its profile. This advertisement is no exception and shared the pages with dozens of local businesses, which unlike Renault are now defunct. (Courtesy Renault Winery.)

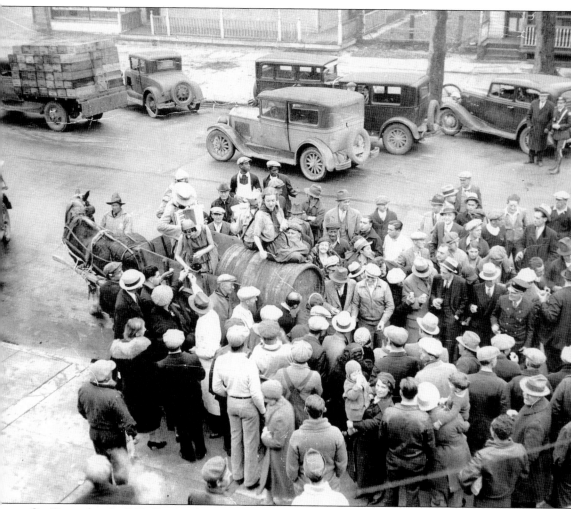

On December 5, 1933, Egg Harbor City citizens celebrate Repeal Day in the street by playing music, dancing, and drinking straight from a barrel of Renault wine. Ironically, America's thirst for alcohol increased during Prohibition, and organized crime rose up to replace formerly legal methods of production and distribution. While proponents of Prohibition argued that the amendment would be more effective if enforcement were increased, respect for the law diminished, and drunkenness, crime, and resentment towards the federal government ran rampant. (Courtesy Renault Winery.)

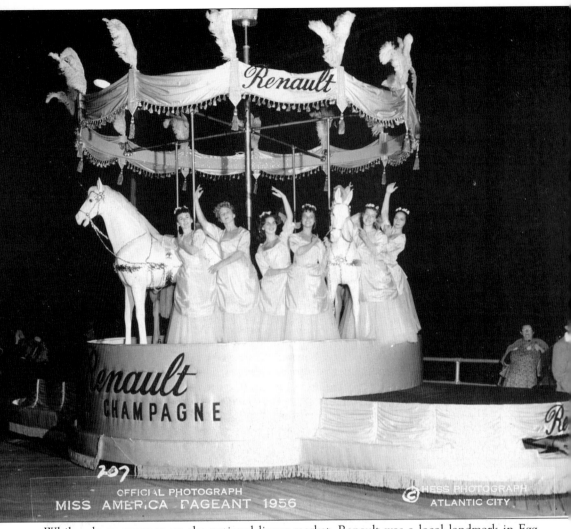

While a huge presence on the national liquor market, Renault was a local landmark in Egg Harbor Township. Here the lovely ladies of the 1956 Miss America pageant promote Renault's biggest seller, champagne, on the Atlantic City Boardwalk. At this time, both the Miss America pageant and Renault Wineries were huge players in the local economy and logical partners for a splashy promotion, long before the casinos sprang up along the ocean. (Courtesy Renault Winery.)

Unidentified young women in 1958 display their trophies after winning one of the many regular beauty pageants held in Atlantic City. Renault Winery was a long-term sponsor of many pageants, viewing the promotional partnership as an opportunity to position their product as the glamorous drink of choice for well-to-do easterners. (Courtesy Renault Winery.)

The Honorable Paul L. Troast, chairman of the board of the New Jersey Manufacturer's Association, and Miss New Jersey 1966 Christine Albright pose in front of a Renault Winery champagne fountain in the Egg Harbor winery. The winery partnered with the local Miss America organization for many years. (Courtesy Renault Winery.)

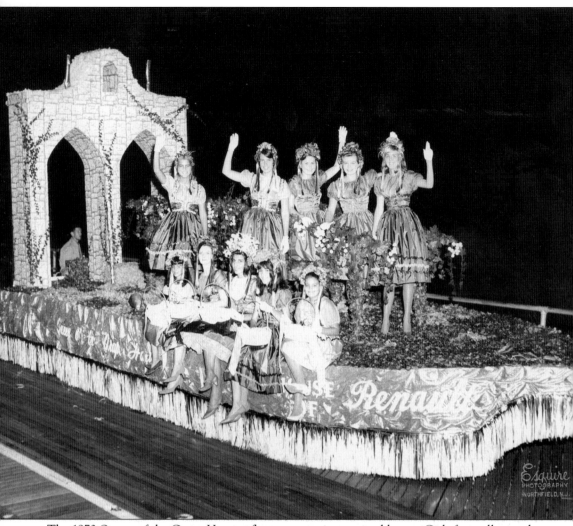

The 1970 Queen of the Grape Harvest float was a serious annual honor. Girls from all over the South Jersey region participated in the promotional festivities. This was just before the era of California wines was launched, which virtually crushed the New Jersey wine industry, including the long-thriving Renault, until its revival in the late 1990s. (Courtesy Renault Winery.)

At the Blue Mirror Night Club in Atlantic City, important men share a drink. The inscription on the back reads: "This club is owned by Mr. David, who is shown in the picture with us. Mr. David had dinner and promised to put a Renault Champagne Cocktail Hour on every afternoon from 2 to 5 p.m. and give Renault preference within his club. He purchased 25 cases of champagne and sparkling burgundy before my arrival and gave us orders for another twenty-five tonight. Money spent in this account will definitely pay dividends." (Courtesy Renault Winery.)

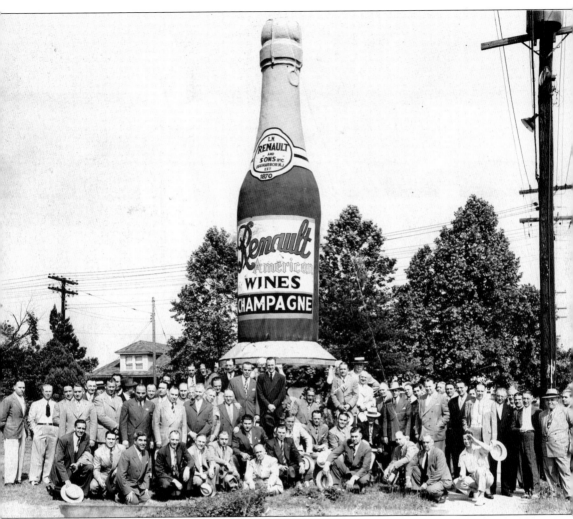

A large group of Renault salesmen and distributors poses in front of the iconic cement bottle of Renault Champagne. Concrete champagne bottles like this, 30 feet high, donning the Renault label were peppered throughout the country in the 1960s. Several of these Americana relics exist today, including this one of the original bottles at the corner of Bremen Avenue and Route 30 in Egg Harbor Township. (Courtesy Renault Winery.)

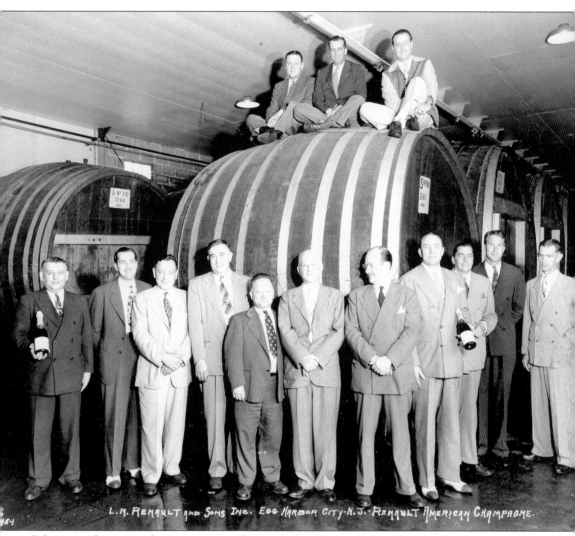

Salesmen often visited wineries to understand the winemaking process and also to shoot promotional photographs. The enormous barrels contained the basic ingredients for Renault's popular champagne. (Courtesy Renault Winery.)

Hee-eee-ere's
JOHNNY CARSON
and the
TONIGHT SHOW

Leading

Renault's
BIG HOLIDAY
CHAMPAGNE
PROMOTION!

POWERFUL . . . FULL COLOR TELEVISION SPOTS!

TV Commercials every night on Channel 3 —
WRCV-TV — now till New Year's!

BIG . . . BRIGHT . . . COLORFUL TRAVELLING ADS!

Saturation Showing of Bus Posters in Harrisburg —
also Philadelphia and Pittsburgh!

**SELLING THE CENTURY-OLD HOUSE OF
RENAULT FOR YOU!**

L. N. RENAULT & SONS, Inc.
Egg Harbor City, N. J.

Seen here is a Johnny Carson advertisement for Renault's big holiday promotion. Renault Winery enjoyed a surge in popularity between the 1940s up through the late 1960s. It was not until California began producing wines and their own versions of champagne, or sparkling wine, that Renault had much competition in the market. At the time of this advertisement, it was a popular commodity among East Coast drinkers. This advertisement ran in the Harrisburg, Philadelphia, and Pittsburgh markets in the new era of television commercials. (Courtesy Renault Winery.)

HOTEL / MOTEL

Dennis
WALTER J. BUZBY INC.
Telephone (Area Code 609) 344-8111

ON THE BOARDWALK AT MICHIGAN AVENUE • ATLANTIC CITY, NEW JERSEY 08401

February 24, 1966

Miss Marie D'Agostino
RENAULT WINERY
Egg Harbor, New Jersey

Dear Marie:

 Thank you very much for the Champagne which you so kindly gave us for our House Party Weekend. The Bon Voyage Party was the first event of the weekend, and it was a roaring success.

 You have been very kind to us and we like to give credit where credit is due, so we tried to get your name before our guests as much as possible.

 I am sorry you missed the Party and it is all my fault. I should have called to see if you were back from your Western trip. We missed having you here with us.

Sincerely,

George H. Buzby
Vice President

GHB:J
encls.

In its ongoing efforts to cross-promote their product as much as possible and as frequently as possible, Renault Winery often donated cases of wine and champagne, which later returned dividends when the hotel or recipient of the "gift" placed massive orders for more. This letter is from the vice president of the Dennis Hotel in Atlantic City, George H. Buzby, in thanks to Renault for support of a "Bon Voyage" party at his hotel. (Courtesy Renault Winery.)

House Party Cruise

THE S. S. DENNIS

FEBRUARY 18, 19, 20, 1966

These are promotional materials for the 1966 House Party Cruise and Renault Bon Voyage Champagne Party at the Dennis Hotel, Atlantic City. The hotel had its own cruise ship that was stocked with plenty of Renault Champagne. The weekend cruise took place in February, but guests were distracted from the cold New Jersey winter with a social schedule that began at 8:00 a.m. and ended at 10:00 p.m. nightly. Acts aboard the ship included Hendra and Ullett, a British comedy duo, and bicycling on the promenade deck. The breakfast menu included whisky sours and Bloody Marys for "the not so athletic." (Courtesy Renault Winery.)

RENAULT BON VOYAGE CHAMPAGNE PARTY

SERVED IN THE LOWER LOBBY
6:00 P. M.

Early and Late Arrivals May Have Their Champagne at the
Fjord Room Bar

NAME..

ROOM NO. ...

NO. 11

Present to Bartender

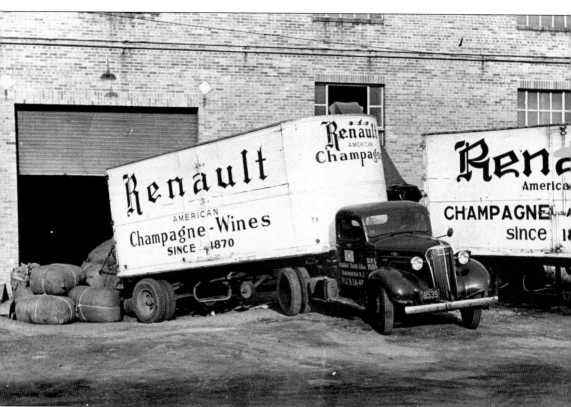

Renault Winery trucks are seen at the loading dock of the winery. Since its founding in 1864, Renault always ensured the family name was imprinted upon everything from stationary to trucks. For the majority of Renault's history, its champagne was a huge moneymaker, so most of the advertising Renault created up through the mid-1970s focused on this product. (Courtesy Renault Winery.)

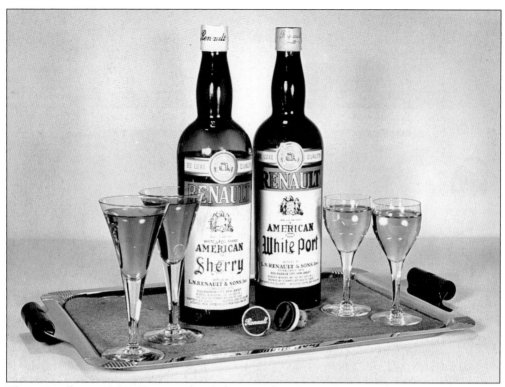

This is a collection of 1965 promotional photography of Renault port and sherry. These would have been submitted to media outlets as well as members of the State of New Jersey Department of Conservation and Economic Development. The photographs were then circulated to liquor distributors and stores to be used in local window displays and press coverage. (Courtesy Renault Winery.)

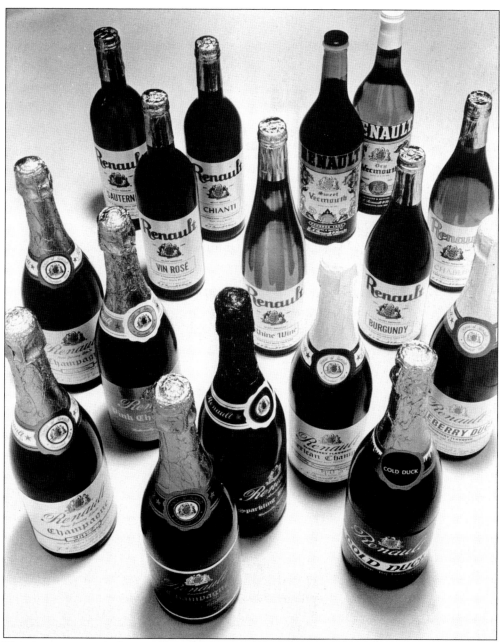

This is promotional photography of the Renault line of wine varieties. At this time, Renault advertised all over the state of New Jersey and in nearby Philadelphia. The winery was producing a variety of wines including light and pink champagnes, red and sparkling burgundies, and American sauterne, Riesling, Chablis, port, sherry, sweet vermouth, tokay, angelica, muscatel, and Madeira wine. Production was at 100,000 cases of champagne and 400,000 cases of wine annually. (Courtesy Renault Winery.)

STATE OF NEW JERSEY
DEPARTMENT OF CONSERVATION
AND ECONOMIC DEVELOPMENT
ROBERT A. ROE, COMMISSIONER

November 22, 1966

DEC 5 REC'D

Mr. J. DeAngelis
L. N. Renault & Sons, Inc,
Norfolk Avenue & Agassiz Street
Egg Harbor City, New Jersey 08215

Dear Mr. DeAngelis:

I am enclosing some photographs of the Press
Preview of New Jersey's Trade Mission/Mobile
Electronic Trade Caravan. Once again I want
to thank you for your assistance.

Our reports from the various countries which
the Trade Mission has visited are most favor-
able and indicate that it is indeed successful.

Sending kindest best wishes.

Sincerely yours,

Robert A. Roe
Commissioner

Seen here is a 1966 letter to John DeAngelis from Robert A. Roe, commissioner of the State of New Jersey Department of Conservation and Economic Development, commending Renault for their participation in a "Trade Mission." These excursions were common methods of introducing state products to other states and countries. Since New Jersey was known for its agriculture, grape crops were seen as a viable product to promote to outsiders. (Courtesy Renault Winery.)

Arthur Raneri, a former New York and Miami Beach maitre d'hotel, conducts a tour. Visitors of all ages received a demonstration of the riddling process that is part of making champagne as well as the entire winemaking process. A steady stream of conventioneers and other visitors came to the winery year-round. (Courtesy Renault Winery.)

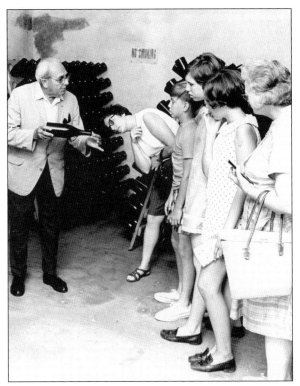

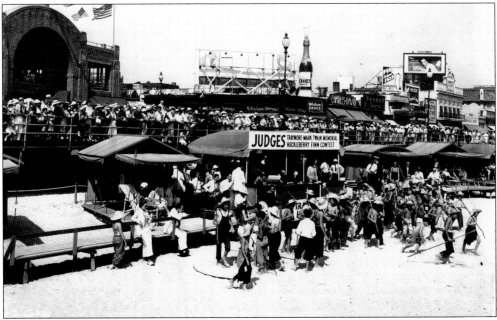

Renault Winery's ubiquitous giant champagne bottle is visible in this photograph shot from the Atlantic City beach toward the boardwalk. Spectators gathered at the lip of the boardwalk to look on as participants in a Traymore Mark Twain Memorial Huckleberry Finn Contest parade in costume. Also visible is the Renault Tavern, illustrating the dominance of the Renault brand at that time. (Courtesy Renault Winery.)

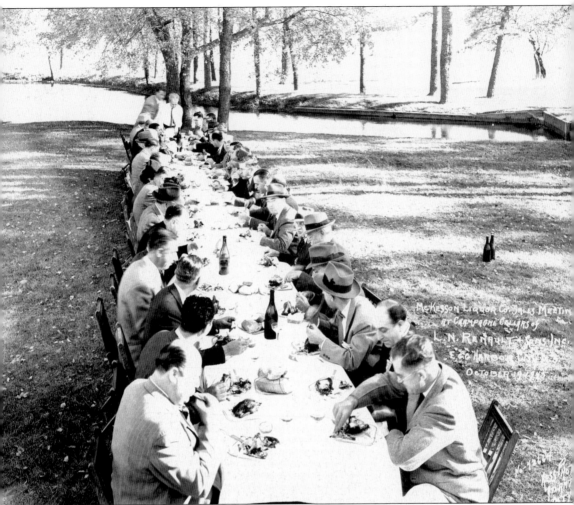

In October 1945, a group of salesmen from the McKesson Liquor Company attended a meeting hosted by their largest client at the time, Renault Winery. In a lavish spread presented by Renault, it was not uncommon for salesmen to enjoy perks such as free cases of champagne, complimentary meals at area casinos, and in some cases, cash incentives to sell more products to the detriment of competitors. (Courtesy Renault Winery.)

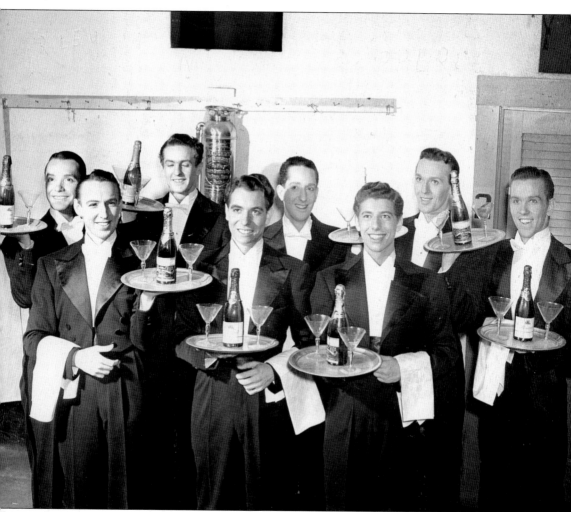

These champagne-bearing, tuxedoed waiters make the world war seem a distant thought. Renault built its fortunes upon its champagne brand and was transparent about how it was made. In an effort to educate the public about its process and to encourage Americans to shun European wines and champagnes, Renault-sponsored parties were regular fixtures on the East Coast social scene. (Courtesy Renault Winery.)

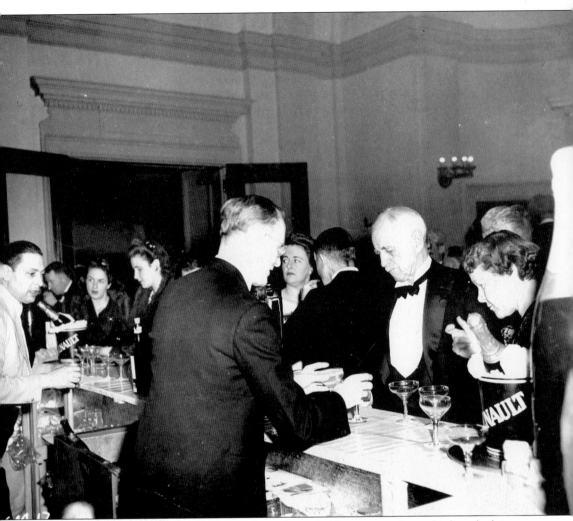

Pictured here is a large, formal party featuring Renault Champagne. Renault's board of trustees was innovative in its guidance of the company, utilizing myriad marketing tools to create brand awareness. Renault Champagne was always served in Renault Champagne ice buckets and often sat upon Renault emblazoned table cloths. (Courtesy Renault Winery.)

Here a champagne fountain is ready for a party at the Renault Winery. Renault was one of the first American champagne houses to use the Charmant process for secondary fermentation. The Charmant process is a French origination of fermenting wine in bulk rather than in the small individual container. (Courtesy Renault Winery.)

This is a promotional photograph of a cluster of the famous Renault Champagne bottles with their foil wrapping. During promotional campaigns from its inception up through the early 1990s, Renault often had to "defend" its bulk processing. The winery's position on the method was that it was superior to and more expensive than other fermentation methods. Competitors charged that the Charmant method was artificially carbonated white wine, much to the chagrin of winemakers at Renault. (Courtesy Renault Winery.)

At a sales meeting of liquor brokers, two unidentified men exchange smiles and Renault Champagne. Despite its occasional lambasting from competitors, salesmen continued to successfully distribute Renault wines, backed by savvy marketing and handsome incentives. Renault thrived and dominated the market for decades, until the rise of the California wine industry and the relaxation of European import taxes made overseas vintages more accessible. (Courtesy Renault Winery.)

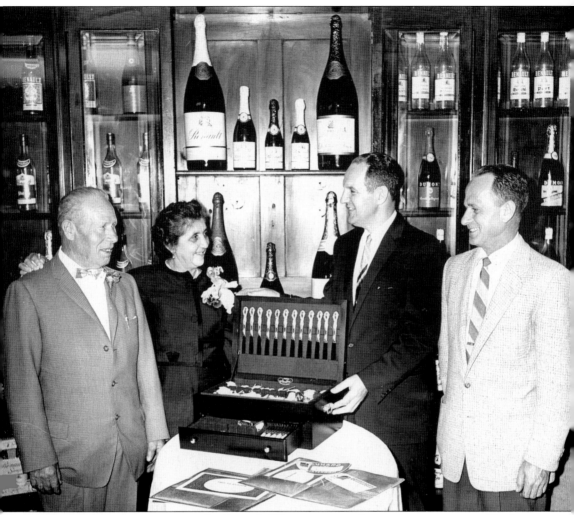

Unidentified guests are seen in the Renault Winery on-site glass and wine museum. By the 1970s, the vineyards had fallen into serious disrepair. Located just inland of Atlantic City, Renault struggled for a place in tourist's plans as the casinos sprung up on the coast. As a drink, California wine was becoming all the rage. (Courtesy Renault Winery.)

A tour guide and an unidentified guest view the collection of antique wine glasses at the on-site Renault wine museum. When New Jersey entrepreneur Joseph P. Milza bought Renault in 1977, its fate was unclear. But over the next 30 years, Renault's land would be cleared and replanted, cultivated, and groomed to continue its winemaking tradition as well as what it is today, a world class gourmet and golf resort. (Courtesy Renault Winery.)

During a break from a New Jersey liquor control board meeting, three unidentified men have a drink and a smoke. The multiple owners of Renault Winery paid much attention over the years to the changing leadership of the New Jersey Liquor Control Board as well as the Pennsylvania Liquor Control Board in order to stay ahead of ever-changing regulations to their fragile industry. (Courtesy Renault Winery.)

Four

A MODERN WINE INDUSTRY IS GROWN

The New Jersey wine industry has faced numerous challenges over its 160-year-plus life. For a period of time in the late 1970s through the early 1990s, winemaking in New Jersey all but stopped. The dawn of casinos in Atlantic City was a strain on other types of tourism to be sure, but it was also the result of the success of the California wine industry. The West Coast vintages simply became more fashionable and the wineries (not to mention the near-perfect weather) had more capital.

But for all its glorious past and troubles, the wine industry was revitalized in the early 1990s, through mass plantings of grapevines and crop changeover to vineyards. These grapes are coming to bear now and today winemaking is thriving in the state. Many wineries are operated by the very same farmers whose ancestors are depicted in earlier chapters. Others are completely new to the industry, having changed careers to try their hand at a lifelong passion. Whatever the motivation, these modern wineries are a vibrant part of New Jersey culture.

New Jersey, like Italy and France, instituted a Quality Wine Alliance program in 1999. The program, called QWA for short, insures that all wines sold to consumers meet set quality standards. New Jersey wines must pass a rigorous review process before they earn the coveted QWA designation. Wines submitted to the prestigious New Jersey commercial wine competition are reviewed by an independent review board consisting of certified wine judges, wine editors, wine distributors, liquor store owners, and experienced wine reviewers. Each wine is sampled to judge its quality. Wines that meet or exceed the requirements are awarded the QWA designation.

To help consumers determine which New Jersey wines have met these high quality standards, a QWA label is now being added to the bottles of wines that have passed this review process. Most all of today's wineries utilize some piece of New Jersey's winemaking past, be it a recipe or wine thief, in a nod to their deep roots in New Jersey's history. Using the modern tool of the Internet, all New Jersey wineries have Web sites. Visitors to www.newjerseywines.com can learn all about the industry.

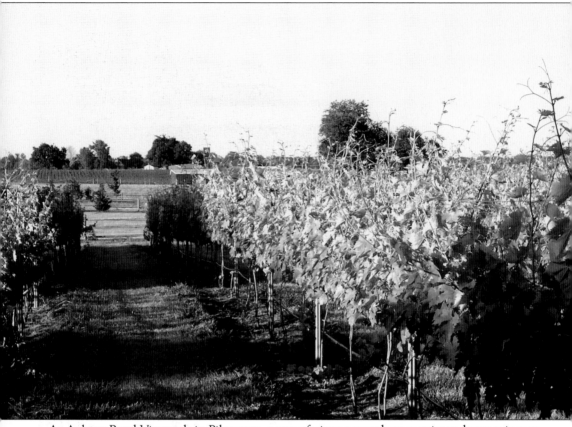

At Auburn Road Vineyards in Pilesgrove, a row of vines a month or so prior to harvest is seen. Auburn Road Vineyard was opened by six partners, three women and three men, who left jobs in the stock exchange and high finance to open the winery. Six varieties of wine went to market for the first time in 2008. (Courtesy Auburn Road Vineyards.)

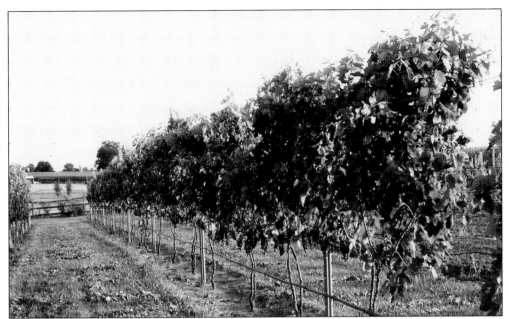

A row of merlot grapes hangs ready for harvest. This southwestern New Jersey vineyard received much expertise from the viticulture studies team at Rutgers University in New Jersey. The owners of Auburn Road Vineyards invested many hours of training and apprenticeship to learn how to plant and grow wine grapes to realize their dream of owning a vineyard. (Courtesy Auburn Road Vineyards.)

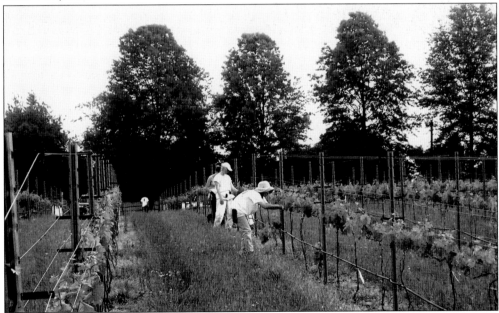

The partners and their friends are seen here on an October weekend thinning leaves from grape vines. Thinning the leaves allows for maximum air circulation at this critical growth point. It is a delicate balance between allowing enough greenery to remain for photosynthesis and enough space between leaves for air to keep the grapes and vine dry. (Courtesy Auburn Road Vineyards.)

Alba Vineyard in Finesville was originally a dairy farm. Its location in a small town in the northern county of Hunterdon places it in the New Jersey viticultural area called the Skylands. Alba, named for the Italian phrase for "beginning of the day" was originally opened in 1982 by the Marchesi family. The winery tasting room is housed in this barn, which was built in 1805. Most of the old stone structure is intact and proved to be a fitting place to make and store wine. Remarkable care was taken in converting the 190-year-old structure into a modern, efficient winemaking facility. The character of the limestone walls and old oak beam framing has not been lost with the installation of modern equipment. All parts of the interior are utilized for some phase of the winemaking process. Steel tanks and modern equipment occupy the bottom and top center of the structure in a fusion of old and new. (Courtesy Kelly Andrews.)

Alba Vineyard owner Tom Sharko (left) and national-award-winning winemaker John Altmaier are seen here. Sharko left a thriving career as a high-end furniture maker in northern New Jersey to invest in Alba Vineyards. The new owner's vision was to plant a lot of vinifera such as chardonnay, Riesling, and gerustameiner. Alba is noted for its 2005 vintages of these wines and has been awarded numerous medals in wine competitions around the United States. (Courtesy Kelly Andrews.)

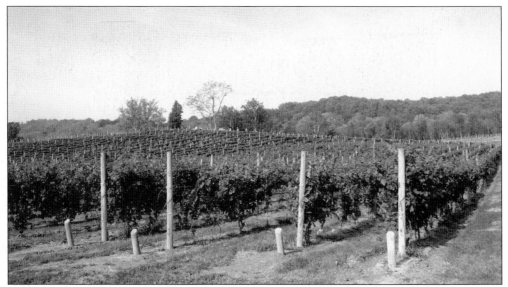

A view of the vineyard reveals pinot grigio and chardonnay grapes ready for harvest. This land was previously covered in forest. Working seven days a week with his sons, owner Tom Sharko cleared dozens of acres of land surrounding the old barn. Because of the slant of the land, certain planting patterns and harvesting schedules must be maintained to combat the extreme northern New Jersey weather. Cold air tends to blow downward, so vines are arranged to allow for maximum air circulation. Clinging frost or moisture is not healthy for the grapes. (Courtesy Kelly Andrews.)

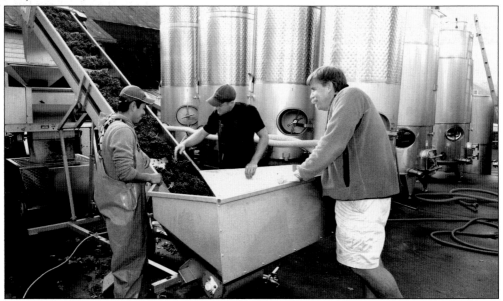

Migrant workers talk with Sharko as they oversee cabernet grapes downloaded from the harvesting belt. Because of the extremely high cost of winemaking equipment, pieces of it are often shared with other wineries so that the costs are defrayed. Or, when wineries go out of business, their used equipment can be a valuable commodity to up and coming wineries. In the case of Alba, many of its machines were secured from former wineries and pieced together to create a fluid production process. (Courtesy Kelly Andrews.)

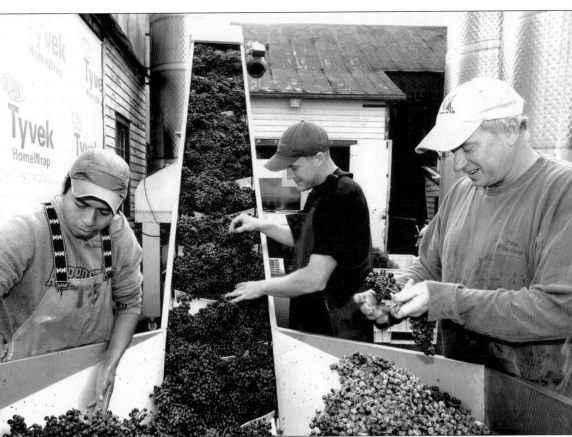

Part of the Alba Vineyard harvesting process is seen here. Although the modern equipment makes the crush portion of grape harvesting much swifter than the past, manual extraction of stems and other natural debris prevents clogging. Like winemakers throughout history, Alba Vineyard winemaker John Altmaier, pictured at right, is involved in every step of the grape's life cycle. It is as likely to see a modern winemaker in the vineyard as it is to see him at the harvest and in the laboratory. (Courtesy Kelly Andrews.)

The picturesque exterior of the Cape May Winery in Cape May is seen here. The Cape May peninsula is a unique locale for growing European wine grapes (*Vitis vinifera*). In the Mid-Atlantic region the weather is quite hostile: too cold, too humid, and too rainy. But lower Cape May has a moderating impact on these weather conditions due to the influence of two large bodies of water, the Atlantic Ocean and the Delaware Bay. It is somewhat similar to the Bordeaux region of France, which lies between the Atlantic and the lower Gironde River, especially the area known as the Medoc. As one might expect, cabernet sauvignon, merlot, and sauvignon blanc do very well in this climate. (Courtesy Kelly Andrews.)

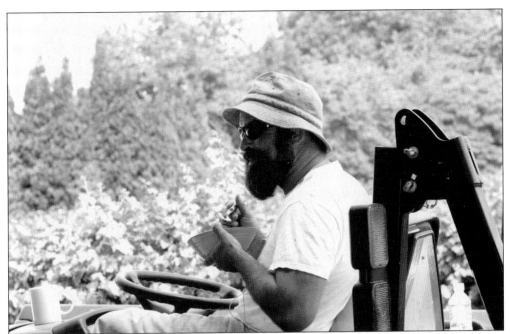

Seen here is a break from the early August harvest at Cape May Winery. Although Cape May Winery is owned by the Craig family, their involvement is not as hands-on as other wineries in New Jersey's history. A fairly busy tourist attraction, this winery is just inland from the ocean. (Courtesy Kelly Andrews.)

This is a stainless steel fermentation tank at Cape May Winery. This particular tank is fermenting a 2006 Victorian Blush semi-sweet wine. The process is intensively overseen by Cape May Winery winemaker Darren Hesington. Temperature is critical to the proper fermentation. Fermentation determines the alcohol content in the wine. Also during this process, the winemaker will routinely taste from this vat to ensure that the recipe he has put into it is blending with time and fermentation. (Courtesy Kelly Andrews.)

The Cape May Winery winemaking laboratory is seen here. Much of winemaking is science. Walk into any winemaker's office and one is likely to find test tubes and beakers sitting alongside a few wine glasses. The process of hand-making wine involves quite a bit of an understanding of chemistry, with the fermentation process and the other elements of wine's journey from grape to glass. Another hallmark of good winemaking is patience. With a minimum of six years time elapsing between a new planting and a harvest, a winemaker has to do a lot of experimenting while he waits for the harvest. (Courtesy Kelly Andrews.)

With the modern wine industry competing against nature, other states, European product, and the fickle tastes of the public, many wineries offer special event hosting on the premises. Cape May is one such place and is one of the busier wineries for wedding ceremonies. The lush soil and weather are good for the grapes and are conducive to growing dense foliage and gardens in the vicinity. These gardens attract birds and bees who can sometimes become a nuisance to the vineyards. (Courtesy Kelly Andrews.)

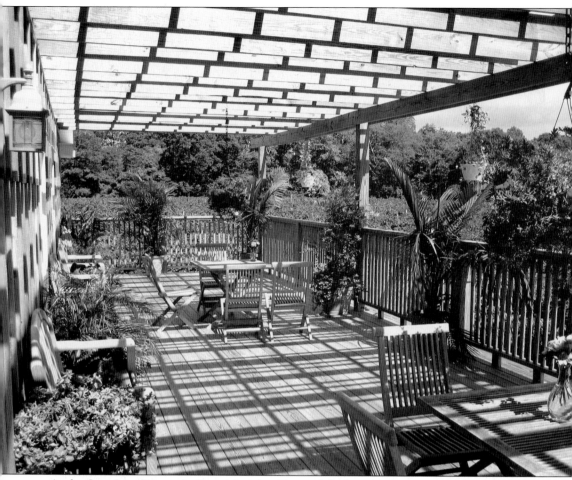

At the Cape May Winery in Cape May, the side porch looks inviting on a sunny May afternoon. This space is often used for special events and weddings and was built by the crew of the winery. The south New Jersey location extends the wedding season sometimes through late December. (Courtesy Cape May Winery.)

The exterior of the Cape May Winery was hand constructed out of local materials by the present winery staff along with a local construction crew. Winery owner Toby Craig opened the winery in 2002 applying his extensive knowledge of the region and of wine, which he garnered as owner of the famous Washington Inn, in the town of Cape May. (Courtesy Cape May Winery.)

This is the exterior of the Cape May Winery as seen from a field located across the street. When Craig purchased this property and another field a mile east of here, the original land deed illustrated that coffin-maker Isaac Smith owned the property. It was upon this property that Smith was the sole coffin maker of the area in the mid- to late 1800s. In honor of this important piece of local history, Cape May winery's premium line of wines is named Isaac Smith. (Courtesy Cape May Winery.)

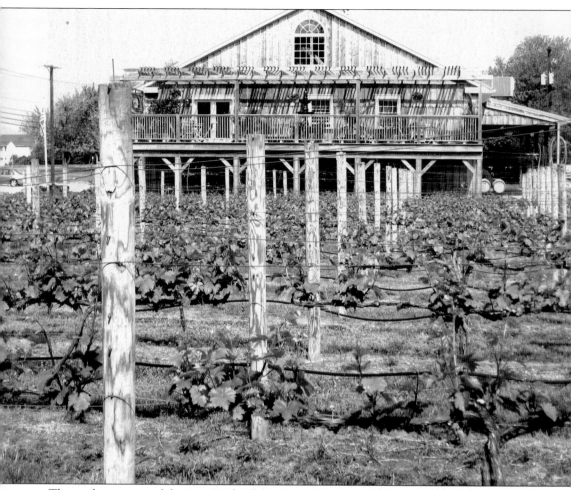

This is the exterior of the rear porch of the Cape May Winery as seen from the vineyard. The winery is a spot for tourists and locals to gather for weddings, picnics, and other special events. Area caterers supply food and local bands offer entertainment in the small tasting area for special occasions. (Courtesy Cape May Winery.)

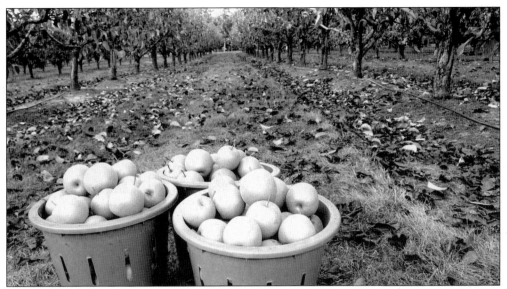

A basket of Asian pears picked from the orchard at Chestnut Run Farm is seen here. The farm started as a specialty farm, growing Indian corn and peaches. Crops then evolved to include baby round eggplant; baby round zucchini; yellow tomatoes; purple, orange, and yellow bell peppers; and several varieties of hot peppers. The primary crop was Gala and Fuji apples. The first pears were planted in 1986, with the idea of exporting high-quality Asian pears to specialty food markets. When that became too highly competitive in the early 2000s, owners Bob and Lise Clark began making Asian pear wine from their crops. (Courtesy Kelly Andrews.)

Seen here is an Asian pear in the Chestnut Run orchard. This pear is a distinct species and is unlike the typical American understanding of a pear, which is that of European descent. This pear is round and exceptionally crispy and juicy. Chestnut Run grows eight varieties of these pears in order to use them as a palate from which they can select a blend to create their wine, similar to grape blending for traditional wine. Three different Asian pear wines are made from the blends: dry wine, semi-sweet, and a sweet spiced wine. Husband and wife owners Bob and Lise Clark are both scientists who apply their pathology and research skills to winemaking with pears. (Courtesy Kelly Andrews.)

A tractor is at rest in the field of Four Sisters Winery at Matarazzo Farms in Warren County. Named for the Matarazzos' daughters, the property is a well-known staple in the local economy, not only for its current winery but also for its apple and pumpkin orchards, which are open to the public. Founded as a produce farm in 1921 by Italian immigrants, it prospered almost from the start. (Courtesy Kelly Andrews.)

Pictured here is Matty Matarazzo in the fermentation room of Four Sisters Winery at Matarazzo Farms. A third generation farmer, he is the first to make wine since Prohibition prompted his grandfather to pull out his vines. Matarazzo's childhood was spent observing the variety of crops that were possible to grow in northern New Jersey soil. In the mid-1980s, Matarazzo Farms was one of the most diversified in the country, exporting vegetables all over the East Coast. Known for their strawberries, it was not uncommon to host 11,000 visitors to their strawberry patches during the harvest. When produce competition became tough, the Matarazzo family began planting wine grapes. (Courtesy Kelly Andrews.)

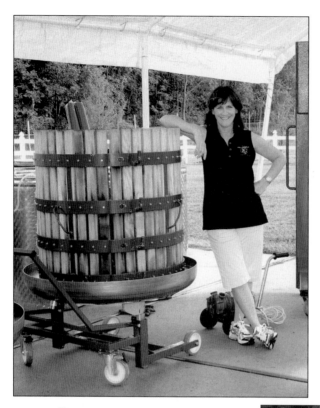

Janet Giunco is part-owner of Four JGs Orchards and Vineyards in Colts Neck. Four JGs is unique in two ways: it is one of only three New Jersey wineries that is part-owned and operated by a woman and it is one of only three wineries in Monmouth County. Its location in Central New Jersey is a historic farming area. The winery is named after the four owners, John and Janet Giunco and their two children, John and Jill. The Giunco family has farmed in Monmouth County for over 60 years. (Courtesy Kelly Andrews.)

This is a view from the vineyard at Four JGs Orchards and Vineyards in Colts Neck. Four JGs was founded in 1999 and is located on a farm with barns and houses that date back to the early 1700s. Four JGs flagship wine is Chambourcin Riserva. The Chambourcin grape is a French hybrid with Rhone origins. It is a winter-hardy variety that has become the favorite of growers in the Mid-Atlantic states. (Courtesy Kelly Andrews.)

Seen here are Penni and Bill Heritage of Heritage Station Vineyards, Richwood. The Heritage family has farmed South Jersey land since 1851. They are the fifth generation farming family on this land. When markets became strained for farmers in the early 1990s, the Heritage family was in jeopardy of losing their livelihood. The family approached the viticultural studies program at Rutgers University to test the viability of cultivating wine grapes. The soil was extensively tested and deemed more than appropriate for a successful planting and harvest. (Courtesy Kelly Andrews.)

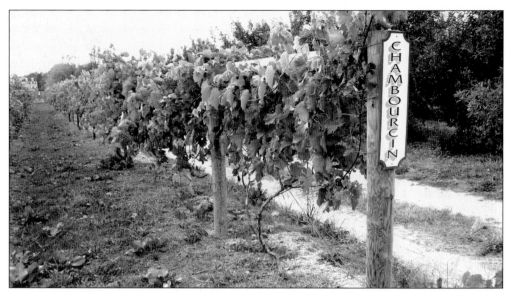

A row of Chamborcin grapevines ready for harvest at Heritage Station Vineyards, Richwood, is seen here. Heritage's grapes and wine are affected to a great extent by the farm's unusual climate. It contributes to the grapes greater concentration of flavor. The early European wine success proved fatal to the farmers; as the commercial vineyards expanded and flourished, the farmers and their families were dispossessed. Appropriately, the winery also produces fruit wine from its own fruit orchards. The Heritage's had once farmed 300 acres of land, which is now reduced to 156 acres. (Courtesy Kelly Andrews.)

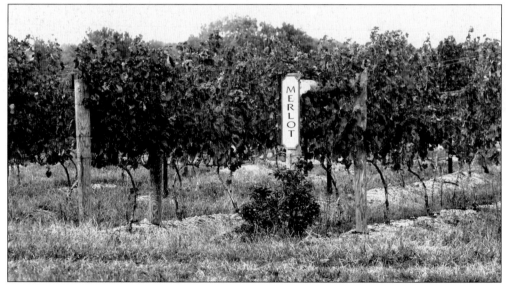

A row of merlot grapes is ready for harvest at Heritage Station Vineyards, Richwood. The winery produces nine varieties of wine, half of which are fruit wines made from the fruit in their orchards. This is a nod to the adaptability of New Jersey farmers who made the successful transition from food crops to wine. Heritage Station also houses a market named Heritage Station to honor the railroad tracks that once bedded across the farm of the Heritage family. Taking account of the customs and rituals of centuries past, the family has found a way to adapt. (Courtesy Kelly Andrews.)

This row of Barbera grapes, a native grape of Piedmont, Italy, is rare to New Jersey. Hopewell Valley Vineyards, Hopewell Township in Mercer County, is a 75-acre farm with 45 of those acres dedicated to viticulture. Hopewell Valley is owned by Italian immigrants Sergio and Barbara Neri of Piedmont, Italy. Growing in the vineyard are chardonnay, pinot grigio, Pinot Nero Chambourcin, Vidal Blanc, and Traminette. (Courtesy Kelly Andrews.)

This is a summer overview of Natali Vineyards in Cape May Courthouse, New Jersey. The vineyards sit on the Delaware Bay side of the state. Eight red, white, and blush wines are produced. Similarities of this lower Cape May region to the Bordeaux region of France are an often noted comparison made by farmers and viticulturists. Weather conditions due to the influence of two large bodies of water, the Atlantic Ocean and the Delaware Bay, make it like Bordeaux, France. (Courtesy Kelly Andrews.)

At Natali Vineyards, rows of vines are meticulously cultivated in order to combat rampant bugs. In southern New Jersey, vines are susceptible to numerous vermin and pests because of the loamy, sandy soil. Special measures are taken to fence off the whole vineyard, and individual plants are often wrapped in special wire to fend off birds who feed upon the grapes. Winery owner Al Natali, and many other South Jersey winery owners, often concoct organic pesticides to kill off bugs and protect the precious plants. (Courtesy Kelly Andrews.)

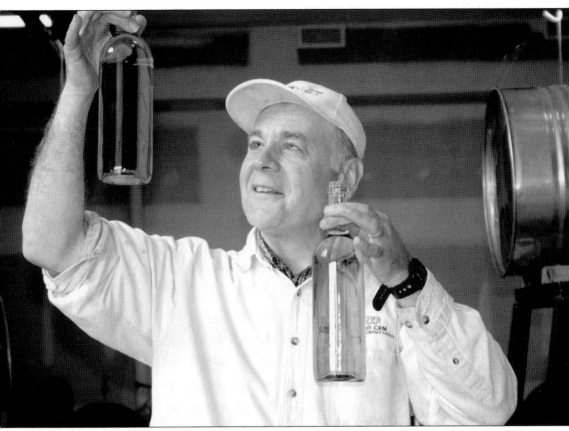

Natali Vineyards owner Al Natali checks out bottles of his blush wine. Natali Vineyards is located along U.S. Highway 47, in the town of Cape May Courthouse. Natali, a retired executive who holds a doctorate in Italian studies from Columbia University, chose the locale not only for its appealing climate but also for the area's notable history. Cape May Courthouse was laid out in 1703 by Jeremiah Hand and was first called Rumney Marsh and afterward Middleton before the adoption of its present name. The Court of Cape May County met in private homes and the First Baptist Church until 1764, when Daniel Hand set aside one acre of his own property to construct a courthouse and jail. Natali and his partners honor the past in the naming of one of their red wines by calling in Cedar Hammock Red after one of the town's former names. (Courtesy Al Natali.)

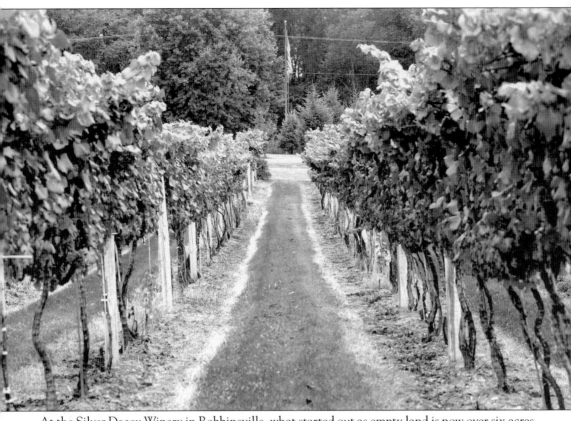

At the Silver Decoy Winery in Robbinsville, what started out as empty land is now over six acres of healthy grapevines. Silver Decoy sits on 15 acres of fertile soil, with plans for expansion. The winery hosts dozens of weddings on the property. (Courtesy Kelly Andrews.)

Seen here are pinot grigio grapes picked for the 2006 harvest at Silver Decoy Winery. These grapes were the first fruit crushed at the winery, which opened in 2005, and each will have a hand in becoming a distinct central New Jersey pinot grigio. (Courtesy Kelly Andrews.)

The winery, which was named Winery of the Year in the State of New Jersey in 2007, is operated by a group of childhood friends with a range of backgrounds. All switched careers to realize the dream of owning a winery. Todd Abrahams, Brian Carduner, Mark Carduner, Scott Carduner, Russell Forman, Richard McIntyre, William Perrine, and Jerry Watlington are the founding members of Silver Decoy. (Courtesy Kelly Andrews.)

The Turdo Winery sign in front of the small Cape May winery was hand built by winery owner and Italian immigrant Sal Turdo in 1998. The winery makes its wine by hand as other true boutique wineries throughout the state. Here white grapes are destemmed and crushed the same day they are harvested, to retain their flavors and aromas. The juice is settled for 24 hours and then the must is inoculated with a yeast strain. The must ferments at cool temperatures for about a month until all of the sugars are used up. Once primary fermentation is complete, the new wine is racked off the lees, into stainless steel containers until next spring when the wine is fined, filtered, and bottled. (Courtesy Kelly Andrews.)

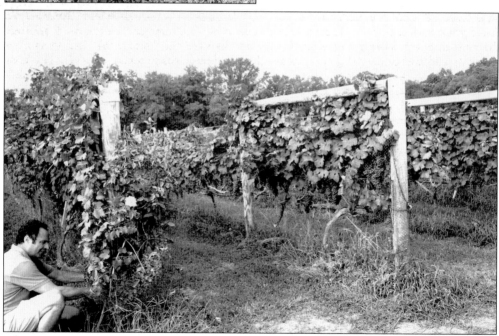

Turdo owner Sal Turdo checks his Nero D'Avola grapes. These are a dark grape, literally meaning "black grape" in Italian, and originate in the warm climate of Sicily. Nero D'Avola are still rather rare in the United States. (Courtesy Kelly Andrews.)

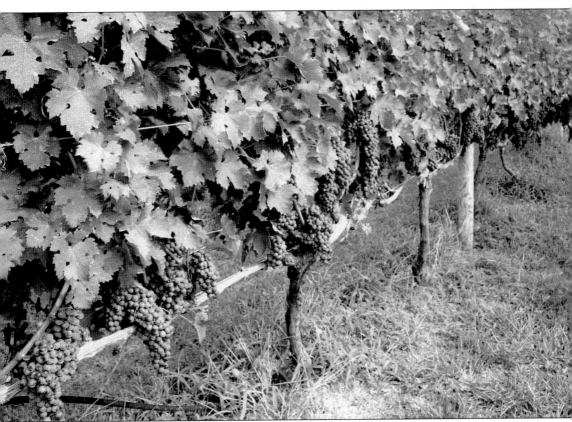

A red grape variety ready for harvest is seen here in the late summer. The sandy soil beneath the grass in South Jersey provides excellent water drainage. As a result, the vines focus their nutrients and energy on the grapes, rather than finding a steady source of water. The final results are grapes that are able to achieve full maturity. At Turdo, like other wineries, red wine is processed differently from white. The grapes are destemmed, crushed, and fermented in the skins ranging from one week to four or more weeks, depending on the type of wine. It is then pressed and moved to stainless steel tanks to settle. After one to two weeks, the wine is transferred to oak barrels, where it ages from 12 to 18 months. During this time, all wines are monitored and checked on a bimonthly basis. Red wines are bottled after 12 to 18 months unfiltered and released three months later. (Courtesy Kelly Andrews.)

At Valenzano Winery in Shamong, Vincent Chung of Philadelphia holds up pinot grigio grapes at the fall harvest picking. Even in modern New Jersey winemaking, most wineries still have to handpick grapes. Perennial crews of migrant workers return to the same wineries, usually several each year to pick the harvest. An unidentified member of Chung's harvest crew works at the Valenzano winery during harvest time. (Courtesy Valenzano Winery.)

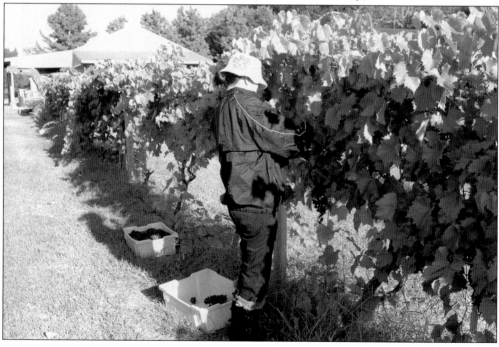

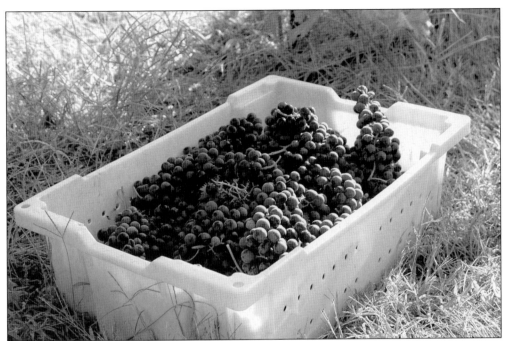

A bin of Chambourcin grapes is seen after being picked off of the vine in October at Valenzano Winery's harvest time. They are dark blue-purple at this time. These grapes are used to make Chambourcin wine, a signature of Valenzano Winery. (Courtesy Valenzano Winery.)

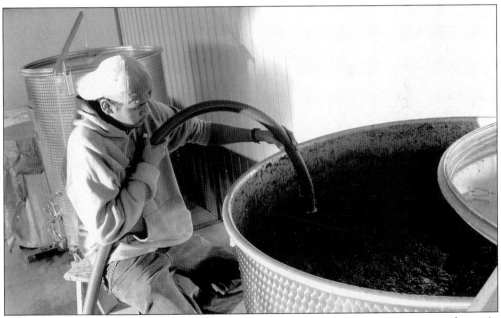

An unidentified employee of the Valenzano Winery pumps out grape must into a steel vat. At this point, the grapes, skins, and juice have been crushed into a large fermenting tank. Yeast is added and fermentation is occurring. The must is being pumped out of the bottom of the tank and back into the top of the tank. This increases aeration and helps fermentation, flavor, and color extraction. (Courtesy Valenzano Winery.)

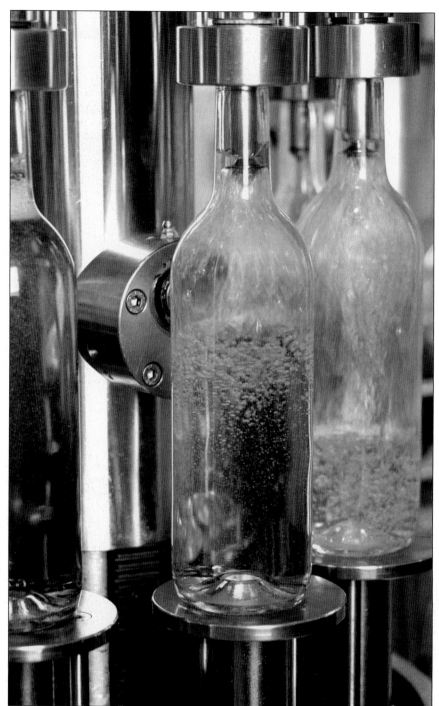

This modern bottling line is immaculate and efficient. A vacuum system purges the bottle with nitrogen, the bottle is filled on the pedestals, the bottle is leveled then corked, then goes to a different conveyor where the shrink wrap capsule is applied, and then the front and back labels are automatically applied. The finished product goes into cases and is stored on pallets. (Courtesy Valenzano Winery.)

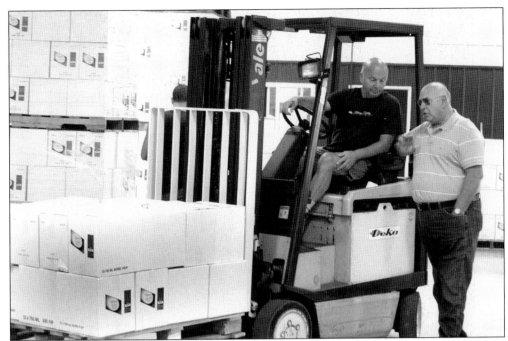

The patriarch of the Valenzano family, Anthony Valenzano Sr. (seated), oversees the ordering and purchasing aspects of the winery, and as most family winery patriarchs, he is well-respected by his sons and crew. The winery sits on what was once his prosperous sod farm. Two other farms on adjacent land were active corn and bean farms. Sons Tony and Mark left other careers to join the senior Valenzano in the winery venture. (Courtesy Valenzano Winery.)

Mark Valenzano sits on a Kubota tractor ready to haul large bins of harvested grapes out of the vineyard. He and other members of the Valenzano family grew up in the sod farming business, among other crops, and had to learn about grape growing from their father and experts at the Rutgers University viticulture program. (Courtesy Valenzano Winery.)

The Valenzano family started farming in Shamong in 1974 and, after a diverse selection of agricultural operations, they started growing grapevines for the family home winemaking needs. These homemade wines became so popular with friends and family they decided to get a license to start selling their wines. Today the winery is a tourist destination, garnering visitors from Delaware, New York, and northern New Jersey. (Courtesy Valenzano Winery.)

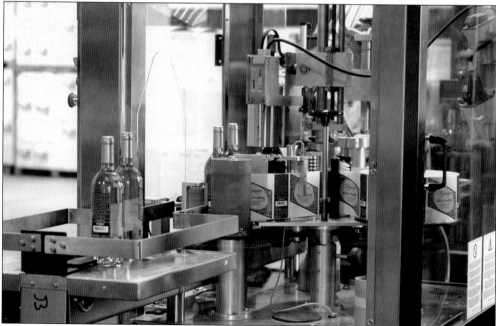

The Valenzano winery labeling line is seen here. The sheer growth of the New Jersey wine industry is exemplified in the quick expansion of the Valenzano Winery. It expanded from one to three locations, with a production facility capable of producing 30,000 gallons and 150,000 bottles of wine per year. (Courtesy Valenzano Winery.)

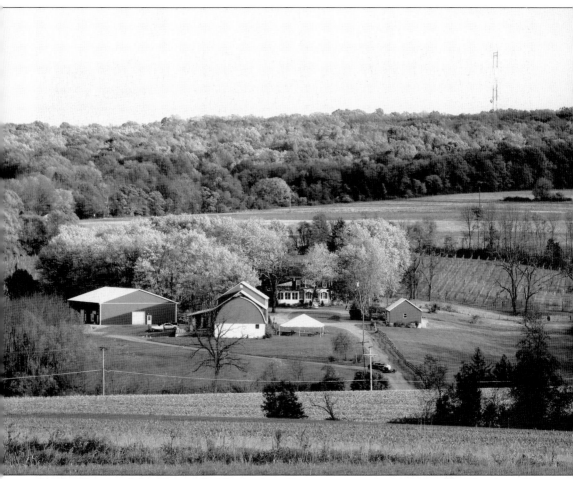

An aerial view of the Unionville Vineyards in Ringoes is seen here in autumn. The Amwell Valley property is owned by Dr. Kris Neilson and has been a part of the local fabric for centuries. With Neilson's expertise at restoration and construction, the property was overhauled and recycled in 1980 with the vision of becoming a vineyard. Local families worked with Nielson in 1976 to research its history in celebration of the bicentennial. The land housed several homes over the centuries. It was first occupied in 1702, about three years after John Ringoes set up his trading post. Remains of Ringoes's cabin are still on the property and were occupied for nearly 100 years. (Courtesy Stephen D. Johnson.)

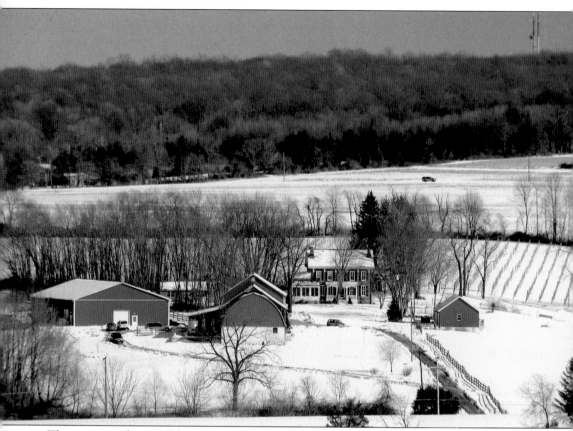

This is an aerial view of the winery and vineyards in winter. Unionville Vineyards is a staple in northern New Jersey tourism, both for its wineries and horseback riding on the land. (Courtesy Stephen D. Johnson.)

The interior of Unionville Vineyards's tasting room is composed of original materials from the property. A second home was built in 1800 where a garden now stands. The third home, constructed between 1856 and 1858, is now part of the winery's tasting area. The original spruce and oak beams were recycled to build the winery bar by hand. (Courtesy Stephen D. Johnson.)

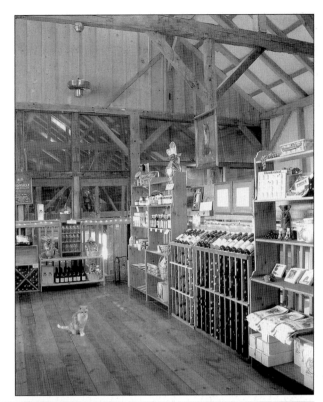

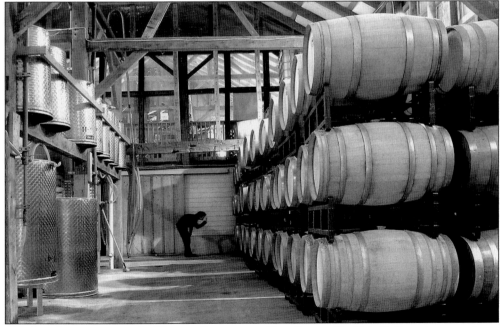

Oak barrels are seen in the Unionville tasting cellar. Owner Dr. Kris Neilson is an engineer by trade; the meticulous layout of the winery's rooms is representative of this. With Neilson's expertise at restoration and construction, the property was overhauled and recycled in 1980. (Courtesy Stephen D. Johnson.)

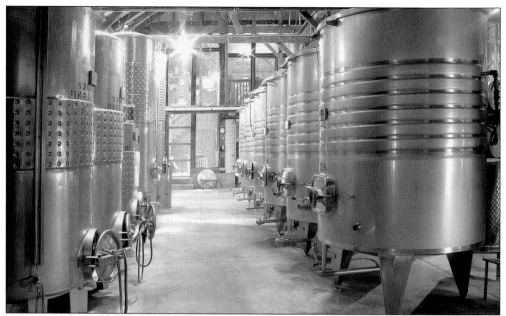

These are the steel fermentation tanks in the main building of Unionville Vineyards. Winery owner Dr. Kris Neilson is an exhaustive researcher and traveler who had collected hundreds of feet of notes about wine and winemaking prior to investing millions of dollars into the winery. These modern tanks are conducive to fine tuning alcohol content and taste. (Courtesy Stephen D. Johnson.)

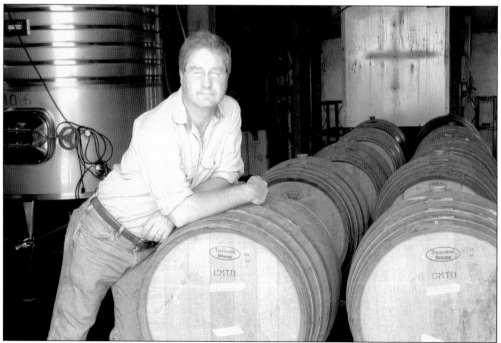

Assistant to the Unionville winemaker, Stephen D. Johnson is also a professional photographer. He works closely with Cameron Stark, a certified enologist from Napa Valley, to create boutique wines. (Courtesy Stephen D. Johnson.)

This is an early fall view of a row of cabernet sauvignon grapes. These grapes will be harvested in late fall. Due to the cold climate in this northern New Jersey vineyard, the grapes need as much extra time in the sun as possible. (Courtesy Stephen D. Johnson.)

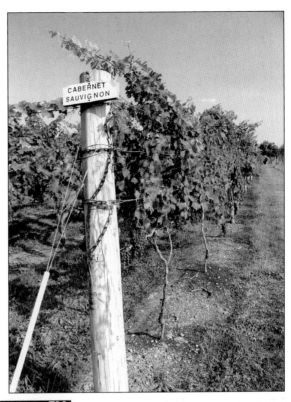

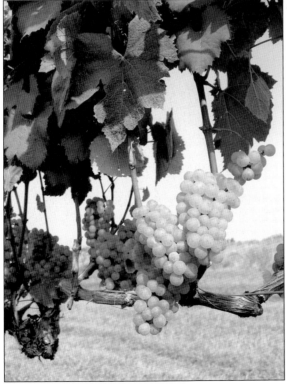

Bunches of chardonnay grapes hang waiting to be harvested in late fall. Unionville winemaker Cameron Stark keeps a close eye on every stage of growth. After a series of winemakers and the usual start-up growth spurts, Unionville lured Napa Valley winemaker Stark back to the east. Stark had just remarried, and the California couple was eager to get back to their East Coast roots. Nielsen was delighted and surprised that a Napa winemaker would want to leave. (Courtesy Stephen D. Johnson.)

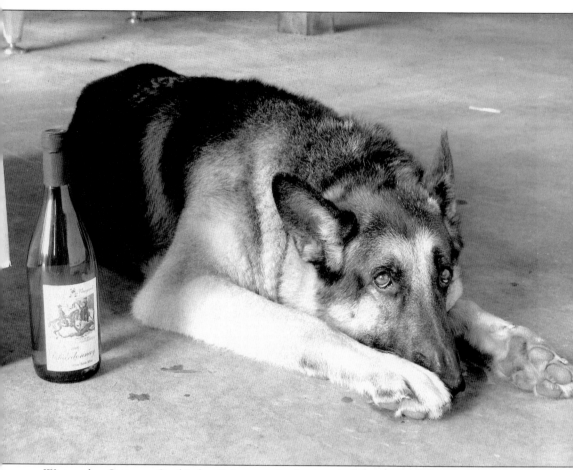

Winemaker Cameron Stark's dog Caine rests in the winemaking room of Unionville Vineyards. Much artistry is involved in winemaking and at Unionville, Stark has much freedom to experiment. Many varieties are grown in one vineyard, allowing for a winemaker's imagination and prowess to be fully challenged. Many California wineries produce just one or two types of wine. (Courtesy Stephen D. Johnson.)

Seen here is Unionville Vineyards's winemaker Cameron Stark. Stark originally hails from New England, but it was a chapter of his life in California that taught him winemaking. Stark is one of the few New Jersey winemakers with an education from the revered University of California, Davis viticulture program. (Courtesy Stephen D. Johnson.)

Assistant to the winemaker, Stephen D. Johnson is in the process of preparing wine to be racked in oak barrels. Many New Jersey wineries, including this one, use a range of oak in which to age wine. Oak from Hungary, France, or the United States is made into barrels and can be used for any range of time, depending on the winery. Some use a barrel once and discard it for recycling; others use the more expensive imported barrels for several vintages of wine. (Courtesy Stephen D. Johnson.)

A seasonal worker at Unionville Vineyard prepares to plant new vines. These would be either new plants or those grafted by the winemaker to create hybrids that will adapt to the climate and soil of northern New Jersey. (Courtesy Stephen D. Johnson.)

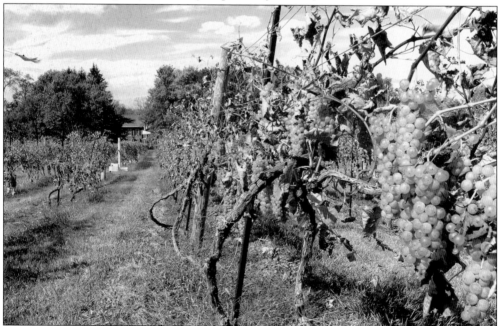

This is a close look at late-harvest vines with hanging bunches of Vidal Blanc grapes. These will be harvested some time in the end of October. All varieties grown at Unionville must adhere to a carefully controlled growing season due to the severe winter temperatures of northern New Jersey. (Courtesy Stephen D. Johnson.)

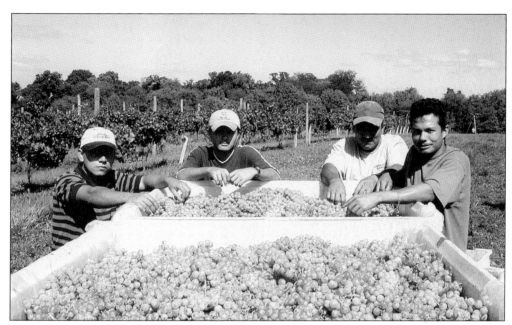

At the Unionville Vineyards, part-time employees look over the bounty of white grapes loaded into bins. At harvest time, New Jersey wineries often hire part-time workers to help pick the thousands of grapes needed to produce wine. (Courtesy Stephen D. Johnson.)

At the Unionville Vineyards, a seasonal employee is working in the pinto grigio vineyard. Local residents with a variety of backgrounds invest many hours in the harvesting of grapes on their off hours from regular jobs. Many teachers, retirees, teenagers, and others from a range of industries come to the vineyard to help with the enormous task of harvesting. (Courtesy Stephen D. Johnson.)

At Unionville Vineyards, just like at other wineries across the state, manual labor is the key to the beginning stages of winemaking. The careful task of selecting and picking ripe grapes is left to the human touch as opposed to high-level equipment. Although it seems tedious, grape picking moves at an intense pace in order to keep the fruit at its peak. (Courtesy Stephen D. Johnson.)

Area residents and tourists relax on a picnic blanket on the winery grounds. Unionville hosts many special public events throughout the year that invite guests to bring their own food and drink Unionville wine on the premises. (Courtesy Stephen D. Johnson.)

Friends celebrate the early harvest at a special public event at the winery. The winery is such a part of the community in its native Amwell Valley that in 1978, as part of nationwide bicentennial celebration, teams of local farmers, teachers, and historians volunteered to research the farm's centennial. (Courtesy Stephen D. Johnson.)

A wine education class is in progress here at Unionville Vineyards. The classes are offered once a month with a particular focus each time. Classes are interactive with local wine experts and include detailed discussion about wines that are tasted at the class. Tasting room staff educates consumers so that their return to the vineyard and wine shop will enable them to make informed purchases. (Courtesy Stephen D. Johnson.)

An unidentified young woman hand packs wine bottles for shipping and storage at the Unionville Vineyards. The vineyards are an example of New Jersey's commitment to enabling farmland to exist in the Garden State, which is the most densely populated state in the country. The property is part of the New Jersey Farmland Preservation Program. The preservation has enabled continued investment in maintaining a viable agriculture family enterprise in one of New Jersey's most historic agricultural areas. (Courtesy Stephen D. Johnson.)

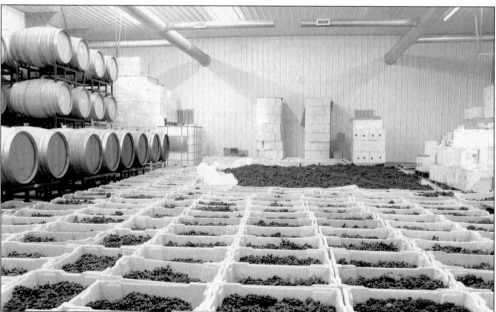

In the Unionville Vineyards production area, cabernet grapes air dry in bins after harvesting. Through careful selection of varieties of grapes and research on clones and rootstock, the agricultural tradition, soils and climate unique to the Amwell Valley, where Unionville Vineyards are located, has enabled production of annually successful grape crops. There are 34 acres under cultivation on the property. (Courtesy Stephen D. Johnson.)

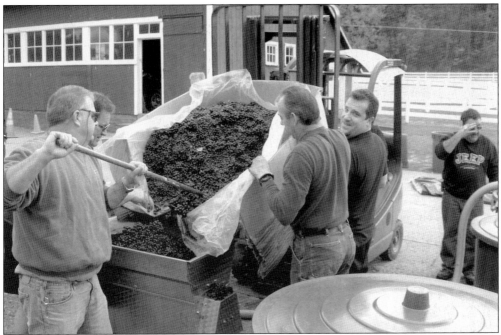

Up north in New Jersey's Westfall Winery, friends unload grapes after harvest as part of a winemaking class offered by Loren and Georgene Mortimer, the current owners of Westfall Winery. It is a far cry from the remote dairy farm it once was. (Courtesy Westfall Winery.)

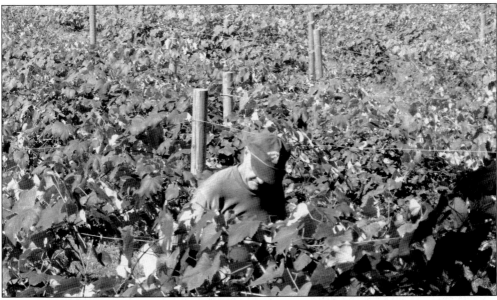

Charles Mortimer, the father of Loren Mortimer, current winemaker at Westfall Winery, is seen in a field of grapevines in the spring. He lives on the property with husband-and-wife team Loren and Georgene Mortimer. Westfall Winery, although relatively small, does a brisk business, but because it is located in the northernmost area of New Jersey, its season is short. During the winter months, the Mortimer family operates another winery in Hilton Head, South Carolina. (Courtesy Westfall Winery.)

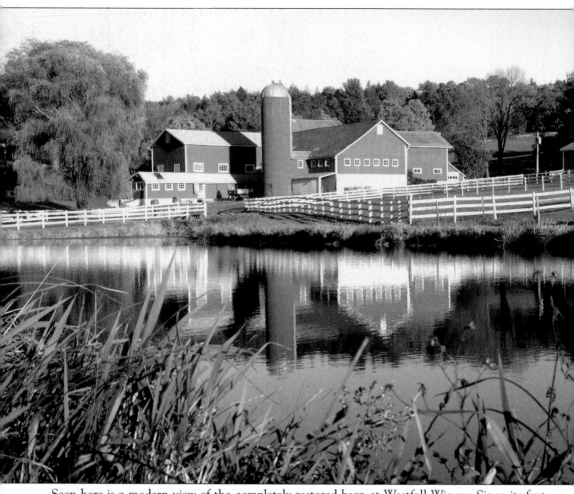

Seen here is a modern view of the completely restored barn at Westfall Winery. Since its first documented purchase by Simon Westfall in September 1774, the land has developed and thrived over the years. The farm and winery are an integral part of the northern New Jersey community of Montague, hosting weddings, winemaking classes, horseback riding lessons, and picnics. (Courtesy Westfall Winery.)

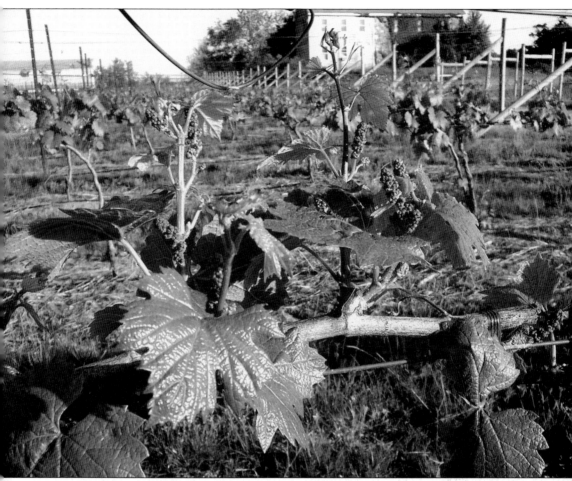

In Logan Township a budding chardonnay grape grows under the May sun in 2007 at Cedarvale Winery. The house and barn in the background are still used today. The barn was originally used to store sweet potatoes from the farm in the wintertime. It is now used to store vineyard supplies such as grow tubes, extra wire, and some equipment. (Courtesy Cedarvale Winery.)

Chardonnay and cabernet franc grapes are in early bloom at the vineyards at Cedarvale Winery. The winery is located in the northwestern-most corner of Logan Township, and although usage of the land as a vineyard is new, the area has not changed too much since it was first documented. As noted in a report of "notable citizens" of Gloucester, Salem, and Cumberland Counties, written in 1888, the soil was, and is, "slightly undulating so as to permit good drainage, the soil a dark, sandy loam which is highly open to cultivation." These characteristics are exactly what are needed to successfully grow wine grapes. (Courtesy Cedarvale Winery.)

A section of merlot grapes is in early bloom at Cedarvale Winery. The farm, of which the vineyards are now a key part, has been in the Gaventa family for four generations. Ed Gaventa and his cousin Roy Gaventa are the present owners. In addition to five acres of wine grapes, the farm currently grows 90 acres of peaches and nectarines, 60 acres of sweet corn, 3 acres of strawberries, and 10 acres of pumpkins. The farm also operates a small roadside market from May to October. (Courtesy Cedarvale Winery.)

ACROSS AMERICA, PEOPLE ARE DISCOVERING SOMETHING WONDERFUL. *THEIR HERITAGE.*

Arcadia Publishing is the leading local history publisher in the United States. With more than 3,000 titles in print and hundreds of new titles released every year, Arcadia has extensive specialized experience chronicling the history of communities and celebrating America's hidden stories, bringing to life the people, places, and events from the past. To discover the history of other communities across the nation, please visit:

www.arcadiapublishing.com

Customized search tools allow you to find regional history books about the town where you grew up, the cities where your friends and family live, the town where your parents met, or even that retirement spot you've been dreaming about.